IMAGES

of Modern America

LIBERTY STATE PARK

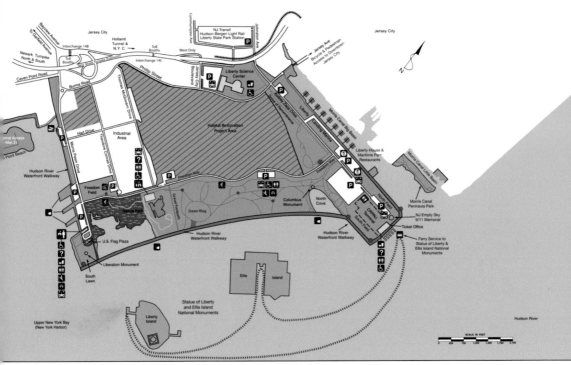

This is the current 2013 map of Liberty State Park. (Courtesy of State of New Jersey Department of Environmental Protection Division of Parks and Forestry.)

On the Front Cover: Clockwise from top left:
Liberty State Park (LSP) CRRNJ Terminal Building (Author's collection; see page 20), geese flying over Statue of Liberty (Author's collection; see page 66), northern corner of Liberty Waterfront Walkway (Author's collection; see page 25), an egret on Southern Walkway (Author's collection; see page 45), spring blooms on Freedom Way traffic-island garden (Author's collection; see page 47)

On the Back: From left to right:
Walking up Cherry Tree hill in spring (Author's collection; see page 29), Southern Walkway (Author's collection; see page 57), Ethel Pesin memorial tree (Author's collection; see page 57)

IMAGES
of Modern America

LIBERTY STATE PARK

Gail Zavian

ARCADIA
PUBLISHING

Published by Arcadia Publishing
Charleston, South Carolina

Printed in the United States of America

Library of Congress Control Number: 2013953620

For all general information, please contact Arcadia Publishing:
Telephone 843-853-2070
Fax 843-853-0044
E-mail sales@arcadiapublishing.com
For customer service and orders:
Toll-Free 1-888-313-2665

Visit us on the Internet at www.arcadiapublishing.com

To my loving sister, Karen, who stands by my side in all things

CONTENTS

ACKNOWLEDGMENTS

To Liberty State Park (LSP) founders and their years of single-minded devotion, sacrifice, and struggles, I express my sincere appreciation and gratitude. I would also like to extend a heartfelt thank-you for the ever-present help of the following people and organizations: the Department of Environmental Protection (DEP), New Jersey Division of Parks and Forestry, LSP; LSP superintendent Robert Rodriguez for rallying support from the DEP and providing access to all Liberty State Park Historical Archives (LSPHA); LSP deputy superintendent Jonathan Luk for his caring support; and Michael Timpanaro, historian of Monmouth Battlefield State Park and LSP historian emeritus who so meticulously and thoughtfully inventoried and created LSP's historical archives. Michael Timpanaro's exacting words and particular expertise were a critical source of authentication.

Thank-you to Dr. Frank Gallagher, director of the Environmental Planning and Design Program, Department of Landscape Architecture, School of Environmental and Biological Sciences, at Rutgers, The State University of New Jersey and former administrator office of the director of the DEP, New Jersey Division of Parks and Forestry, for detailing the evolution of LSP's unique urban ecology. Dr. Gallagher's impassioned commitment fostered my deeper involvement with LSP and its marvelous "Interior" area. Thank-you to railroad historian William J. "Capt. Bill" McKelvey, chairman of Liberty Historic Railway, whose railroad knowledge could fill 10 volumes!

A special thanks goes to Sam Pesin, president of Friends of Liberty State Park (FOLSP), whose love for and total commitment to LSP and personal sense of responsibility toward this project contributed to its successful completion. May that love he shared be returned to him in the same way it was offered.

This small volume only touches upon LSP's expansive history. I hope it inspires you to investigate further, become acquainted with, and perhaps visit and enjoy this magnificent park behind Lady Liberty. To all, I wish peace profound.

A portion of the proceeds of this book will be donated to FOLSP.

Unless otherwise noted, all images appear courtesy of the author, Gail Zavian.

INTRODUCTION

Liberty State Park's physical features, biology, history, culture, and future plans have evolved from the site's beginnings as an active and unique waterfront transportation hub. Originally called Communipaw Cove by the native Lenape people and early Dutch and English settlers, this peaceful area was known for its oyster beds, fine fishing, and safe harborage. As the 19th century's growing Industrial Revolution created the need to reach larger markets, the Central Railroad of New Jersey (CRRNJ) purchased and began filling Communipaw Cove's shallow mudflats and tidal salt marshes. From 1860 to 1928, using ballast from oceangoing vessels, New York City and Jersey City construction debris, and almost 200 million cubic yards of malodorous trash, the CRRNJ was able to gradually fill the cove, extending the land out toward deeper Hudson River waters. Functioning as the premier connection between both rail and ferry modes of transportation for over 100 years, the area represented the industrious energetic spirit of a growing free America.

By the mid-1900s, the shift from coal to oil and gas and the construction of the Holland and Lincoln Tunnels, George Washington Bridge, and better highways contributed to the CRRNJ's decline. Bankrupt by 1967, the 1.5-mile-long railroad/marine complex was abandoned, leaving its nearly 100 miles of crisscrossing rusting railroad tracks, a train shed, station and ferry houses, and the surrounding remnants of its past to further deteriorate alongside a rotting web of docks, piers, aging tugboats and ferries, broken barges, an assortment of discarded water and land debris, and a group of abandoned guard dogs that combined into a notorious wild pack. The site's future, however, had already been cast nine years earlier. In 1957, after a frustrating three-hour family outing from Jersey City through New York City to the Statue of Liberty, local businessman, activist, and "father" of Liberty State Park, Morris Pesin, had a visionary plan for what would evolve into a beautiful park on the Jersey City shoreline with access to Lady Liberty. His personal crusade to create a park with a 2,000-foot causeway connecting Jersey City to Liberty Island began the following year. On June 13, 1958, at the suggestion of Eugene Farrell, editor of the *Jersey Journal*, Morris Pesin kicked off his campaign by staging a canoe ride from Jersey City's debris-strewn Black Tom waterfront, accompanied by a *Jersey Journal* reporter. The trip was accomplished in only eight minutes!

In the 18 years that followed, Morris Pesin was joined by a committed group of citizens. In 1962, he and fellow advocate Theodore Conrad, a nationally known architectural model maker, formed the Statue of Liberty Causeway and Park Association, Inc. The goal was to spread the word about an open-space "people's park" by showing an effective tree-filled model, which was financed and created by Conrad. With growing support in Trenton and Hudson County, they were joined by the Hudson County Citizens Committee, which included Jersey City historian Owen Grundy and LSP "godmother" Audrey Zapp. In 1965, two milestones marked the beginning of the creation of LSP. Pres. Lyndon B. Johnson declared Ellis Island part of the Statue of Liberty National Monument, promising $6 million to beautify the "immigrant gateway" and the area of Jersey City behind it—the future site of LSP. That same year, Jersey City transferred to the State of New Jersey 156 acres,

including the area known as Black Tom, which was the eventual early nucleus of LSP. Elements of the CRRNJ Terminal Complex remained deserted and decaying until Morris Pesin, Ted Conrad, and Audrey Zapp convinced state and federal officials to preserve the terminal buildings, along with the conversion of the entire site to a park. In 1968, the CRRNJ Terminal Complex was purchased with state and federal funds. The state continued to allocate Green Acres funding for land acquisition. On opening day, Flag Day, June 14, 1976, New Jersey's governor Brendan Byrne declared Liberty State Park as "New Jersey's bicentennial gift to the nation."

Over the ensuing decades, with the help of conscientious advocates who fought to keep LSP free, noncommercialized, and nonprivatized, LSP has expanded and evolved.

Parcels of land were purchased and developed, adding to the park's inventory. Inspired by the area's history, the importance of evolving and sustaining a land-use ethic was integrated into LSP's land development. The 251-acre center area of the park, called the Interior, is the site of a unique habitat restoration project that includes freshwater wetlands, a salt marsh, and a forest. Formerly a railroad yard abandoned for over 40 years, the Interior has become a "living lab," remaining fenced in and undeveloped, as plans to turn it into a very special ecological reserve continue. When completed, it will provide the world with an exemplary model of urban natural habitat restoration. Visitors will be able to enjoy up-close access into a revived and thriving landscape.

An ongoing relationship with citizens ensures the park continues to stay true to the fundamental goal that called them to action, namely preserving and protecting a free and open space for the public. The park's reputation and amenities, such as Liberty Science Center, two award-winning restaurants, Liberty Landing Marina, and an awe-inspiring portion of the Hudson River Waterfront Walkway, draw millions of visitors, both locally and worldwide, to experience its spectacular views of Lady Liberty, Ellis Island, New York City, the Verrazano Straights, and the harbor.

The parkland's nature and history has endowed the area with unmatched grandeur and meaning. Not only has the creation of this magnificent park behind the Statue of Liberty been the greatest restorative influence impacting Jersey City but also, for all who visit, it remains a place of peace, harmony, and inspiration. Visitors are encouraged to bring their lunch, stroll, jog, sit, picnic, fish, kayak, play ball, toss Frisbees, stay a while, and enjoy this glorious gift from the people to the people. Liberty State Park, a reclaimed wasteland but now a beautiful and free urban waterfront park, has become a new American landmark!

One

CHANGES IN THE LAND

Communipaw Cove stretched from the Morris Canal on the north to Caven Point on the south. Pennsylvania's coalfields and New Jersey's iron mines connected with New York City's commercial markets via the Morris Canal, but the canal could not compete with the faster and cheaper railroads, which could also operate in winter. The CRRNJ began filling Communipaw Cove's marshland and intertidal flats, creating land on an "as needed" basis. By using debris material and ship ballast as fill, dredging the surrounding waters, and digging up the bottom of the marshes, water was created deep enough for boats, barges, and ferries to dock. By the turn of the 20th century, CRRNJ had become the largest railroad/maritime complex in the New York Harbor, its boundaries extending far beyond the natural shoreline into the Hudson River.

The state's decision to move forward with the creation of LSP began with the consideration of the site's historical value. Soil and groundwater contamination could not be overlooked. Contractors and engineers were brought in to determine the soundness of remaining structures and the feasibility of "historic fill" becoming green public parkland. The majority of the CRRNJ railroad/maritime complex buildings were found unsuitable for restoration and were demolished. Most of the remaining cleared areas became extensive brownfields, but by 1976, a total of 35 acres had been developed and officially opened as LSP.

Bordered by water on three sides, north by the Morris Canal and south and east by Upper New York Bay, LSP now consists of 1,212 acres, with 600 acres classified as land and the other 600 as water. The natural substrate at LSP is approximately 30 to 40 feet below the surface. Though LSP's grounds are all railroad expansion-era landfill covered by a two-foot layer of safe clean fill required for healthy public use, dig down 20 feet and one will find the fragments of salt marsh made of silt, clay mud, and oyster shells.

CHANGES IN THE LAND

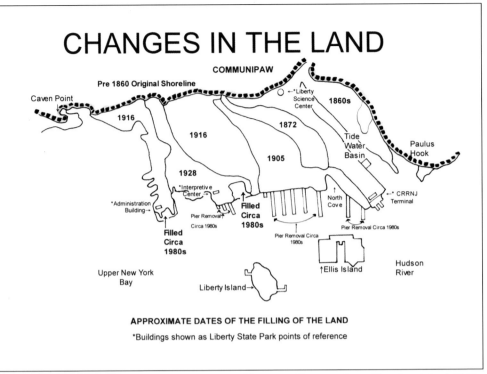

COMMUNIPAW

Pre 1860 Original Shoreline

Caven Point

1916

1916

1928

*Interpretive Center

*Administration Building→

Pier Removal↑ Circa 1980s

Filled Circa 1980s

Filled Circa 1980s

1872

1905

← *Liberty Science Center

1860s

Tide Water Basin

North Cove

Filled Circa 1980s

Pier Removal Circa 1980s

Paulus Hook

←* CRRNJ Terminal

Pier Removal Circa 1980s

Upper New York Bay

Liberty Island→

↑Ellis Island

Hudson River

APPROXIMATE DATES OF THE FILLING OF THE LAND

*Buildings shown as Liberty State Park points of reference

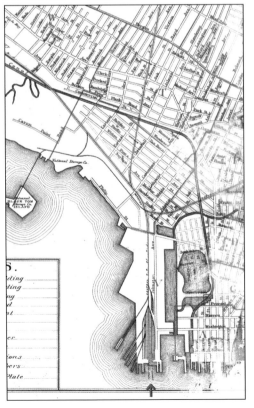

Shown is Communipaw Cove's original 1860s shoreline compared to present-day LSP's. It represents the timeline and extension of the area by CRRNJ to accommodate the evolving rail/maritime needs. LSP's soil, called "historic fill," often unearths artifacts such as glassware, domestic items, and 12-inch oyster shells. (Illustration by Gail Zavian.)

CRRNJ built its first 1864 wooden terminal on pilings on the tidal flats. A wooden trestle led out to it. This 1887 Jersey City atlas shows the L-shaped facility with three ferry slips and a pier. Note today's Phillips Street is behind LSP's Interior! (Courtesy of Jersey City Free Public Library.)

The blue stripes in this 1890 map of Jersey City represent marshlands and creeks no longer in existence. Much of the area was swampy and yet to be filled by the railroads. Liberty Island is depicted with its original name, Bedloe's Island. (Courtesy of Andrew Bologovsky Historical Jersey City Collection.)

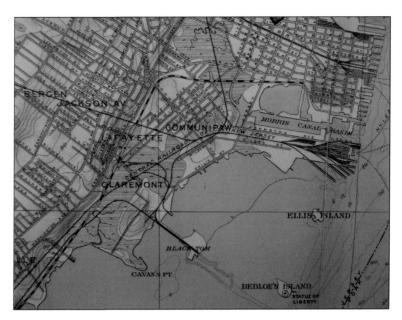

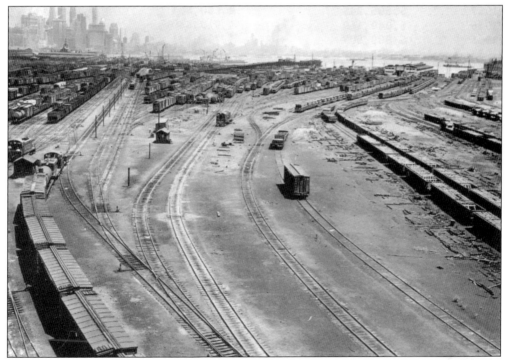

This 1958 panorama taken from the top of the yard tower shows the passenger terminal (upper left), freight piers (right), and Ellis Island (extreme right), which is distinguished by its water tower. The present-day Interior stretches across the bottom of photograph. (Courtesy of Jersey City Free Public Library.)

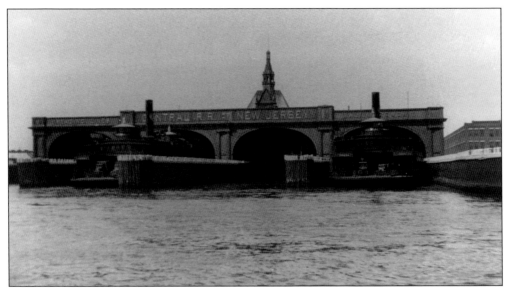

The Central Railroad of New Jersey's ferry shed, shown here in front of the terminal head house, provided weather protection for commuters as well as the float bridges connecting the land with the ferries. The protective ferry shed was demolished, causing the float bridges to disintegrate. (Courtesy of LSPHA.)

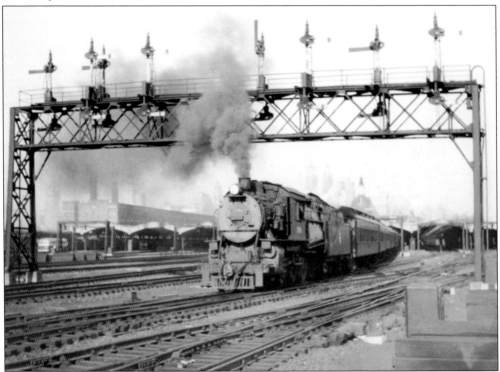

This CRRNJ "Camelback" steam locomotive, which hauled passenger trains, departs CRRNJ's terminal train shed, passing under one of the many signal bridges with semaphores, which controlled train movements. To the extreme left is a B&O "Train Connection" bus. This area is now a parking lot. (Courtesy of LSPHA.)

The crescent-shaped building is a surviving segment of CRRNJ's double roundhouse, which was the largest ever built in New Jersey. Behind it is the engine terminal powerhouse, the present-day location of the Liberty Science Center Building. On the left is the New Jersey Turnpike. (Courtesy of Andrew Bologovsky Historical Jersey City Collection.)

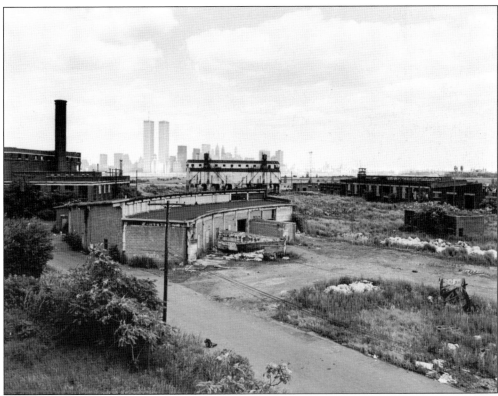

Shown is a portion of CRRNJ's double roundhouse, which included a locomotive maintenance shed built around a turntable. Behind it is CRRNJ's concrete steam locomotive coaling station, the largest ever built in New Jersey. In the distance are the Twin Towers of the World Trade Center. (Courtesy of Andrew Bologovsky Historical Jersey City Collection.)

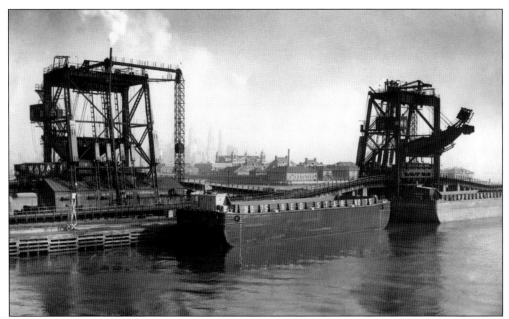

Shown here are two views of CRRNJ's twin McMyler "Big Mac" coal dumpers. This state-of-the-art coal-transferring system operated in the vicinity of LSP's Interpretive Center. In the image above, Ellis Island appears to the east of the dumpers. The dumpers rotated the railroad coal cars emptying their contents by gravity down a chute into marine vessels for delivery to waterside customers. The McMyler loader performed its first day's work for CRRNJ on July 1, 1919. In 1976, CRRNJ demolished these structures, salvaging the scrap to help pay off its bankruptcy debt. (Courtesy of Jersey City Free Public Library.)

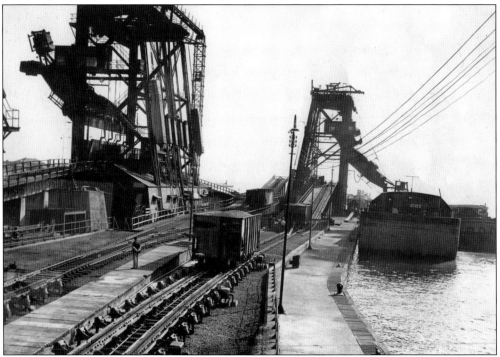

A 1930s watchman guards the site that eventually became LSP. (Lady Liberty is in distance.) After the railroad's abandonment of the area, it was rumored that one of the guards carried a sawed-off shotgun filled with rock salt to dissuade looters . . . or perhaps it really was to protect himself from the also abandoned watchdogs! (Courtesy of Andrew Bologovsky Historical Jersey City Collection.)

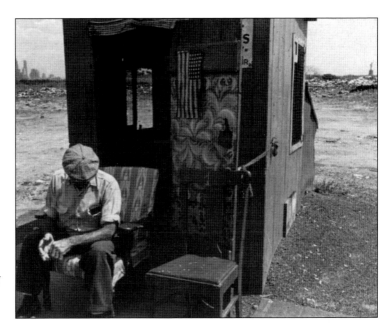

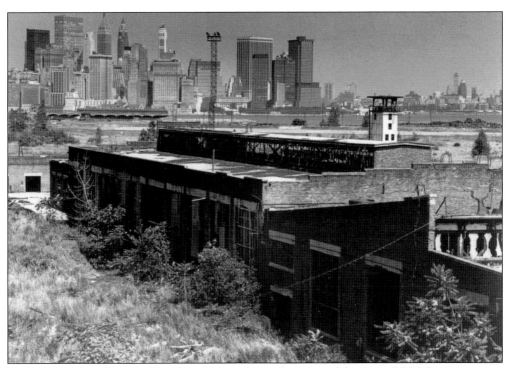

In this view taken from the New Jersey Turnpike viaduct, one of the many CRRNJ maintenance structures is in the foreground. The six-story yard tower is to the right of the center, and the terminal train shed can be seen in the upper left. (Courtesy of Andrew Bologovsky Historical Jersey City Collection.)

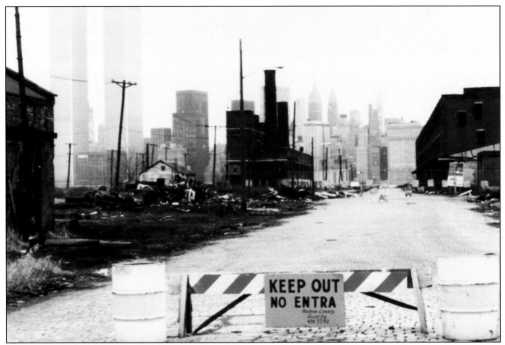

This view from Johnston Avenue, named after the longest-running CRRNJ president, shows the marine basin, the present-day location of both LSP restaurants and Liberty Landing Marina. The terminal powerhouse on the left, Express Building on right, and the World Trade Center's Twin Towers are all gone. (Courtesy of LSPHA.)

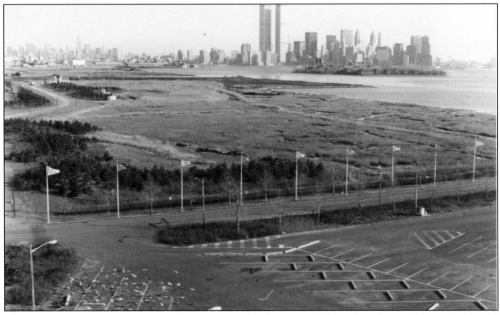

The 40-acre natural area surrounding LSP's South Cove, including the salt marsh, was dedicated to Richard J. Sullivan on November 22, 2005. The Nature Interpretive Center is at top left. The south parking lot and row of state flags are along Morris Pesin Drive. The walkway has yet to be built. (Courtesy of LSPHA.)

This 1980s view shows Freedom Way, the main north/south road through LSP, yet to be paved. Traveling this route leads past the Nature Interpretive Center and gazebo (top) and ends at Morris Pesin Drive (bottom). Freedom Field (left) is the site of the future covered picnic pavilions. (Courtesy of LSPHA.)

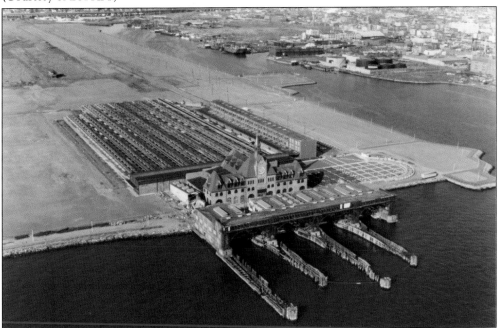

This aerial shows the passenger terminal complex following removal of all tracks and nearly all freight and structures. The long, three-story brick structure to the right of the train shed is the former Express Building. The Morris Canal Big Basin on the right is now Liberty Landing Marina. (Courtesy of LSPHA.)

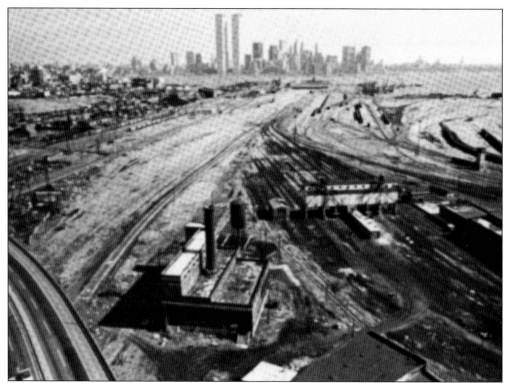

CRRNJ's engine terminal power plant is in the foreground. The coaling station and yard tower are to the right. Only one of the multiple main line passenger tracks leading to the terminal remains. Liberty Science Center was built on the site of the power plant. (Courtesy of LSPHA.)

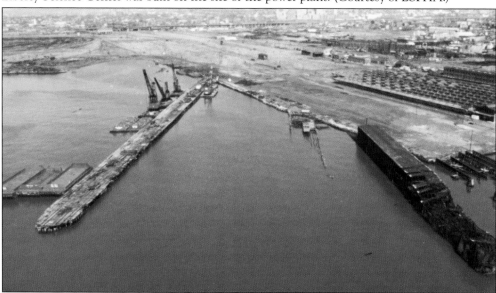

Shown are remnants of CRRNJ's piers before removal. These two active components were located south of the terminal and train shed. The crescent-shaped shoreline (upper left) is known as LSP's North Cove. The waterfront promenade leads along this shoreline with a bridge passing over the North Cove's inlet. (Courtesy of LSPHA.)

CRRNJ Terminal, or head house, the linking element between the ferry concourse and ferry shed on the east with the trains on the west, contained ticket counters, telegraph rooms, men's and ladies' waiting rooms, restaurants, and the ever-necessary newsstand. Shown here is the former Union News Company. (Courtesy of LSPHA.)

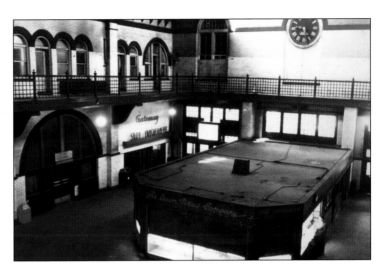

Architects Peabody & Stern redesigned the CRRNJ Terminal in 1886. French Renaissance in its exterior, internally the 1889 terminal exhibited the strength of the Romanesque style. This 1970s Geddes's rendering shows a new design concept for the CRRNJ. Geddes also created over five other redesigns for LSP, including The Crescent–Solarium Walk and A Farmer's Market–Gardens of the Garden State. (Courtesy of LSPHA.)

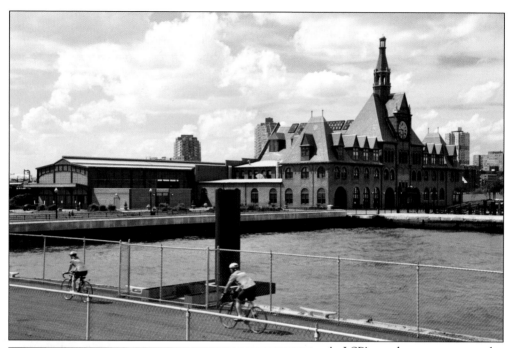

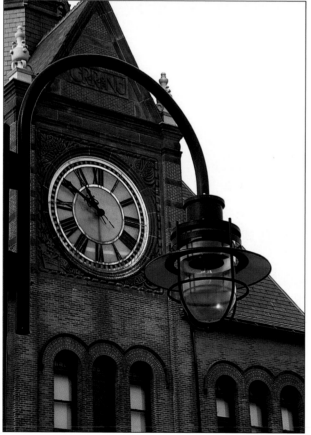

At LSP's northeastern corner, the terminal's structure of redbrick and iron stands prominently—the last vestige of Jersey City's huge harborside railroad development era. Considered one of the finest railroad/maritime complexes, it is a rare architectural type unique to only two areas of America—San Francisco and the New Jersey/New York City Harbor.

The terminal's tallest roof is capped with a cupola containing a magnificent Harvard clock placed where passengers on incoming and outgoing ferryboats could check the time over the low, single-story, ferry houses. A square stone surrounding the clock's face has corner embellishments with the words science, agriculture, commerce, and industry.

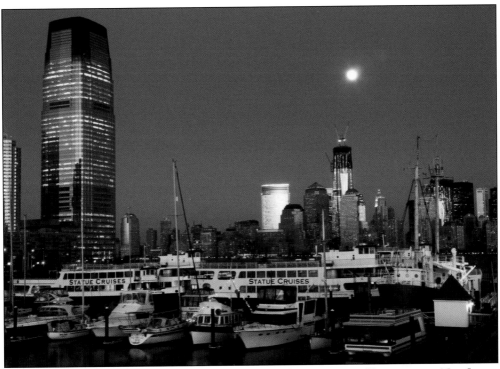

Liberty Landing Marina, part of the old Morris Canal that once moved barges across New Jersey, leases its land from LSP. It is the only 520-slip "calm-basin" full-service marina for boat dockage in the Hudson River. New Jersey's tallest building, Goldman Sachs, is shown at the left.

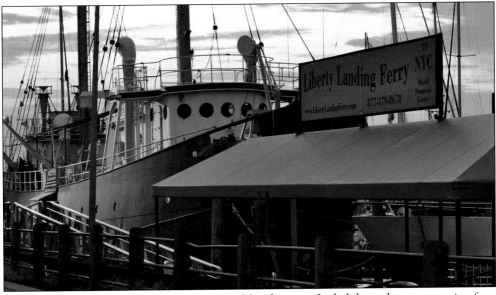

In September 1977, the first ferry connecting New Jersey to Lady Liberty began operating from LSP's southern end. Now running from the northern docks of Liberty Landing Marina, a privately owned Suntex Marina facility, the Statue Cruises affiliate *Little Lady* provides ferry service to and from New York City. The Light Ship Winter Quarter LV 107, commonly called the "Red Light Ship," contains the marina offices.

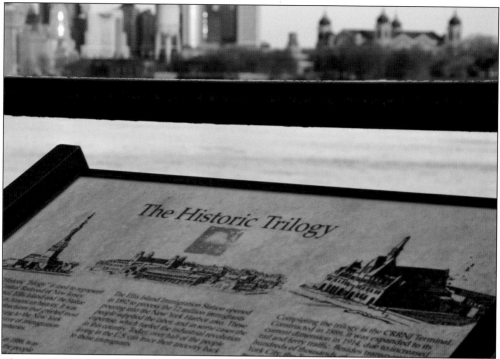

The CRRNJ Terminal stands with the Statue of Liberty and Ellis Island Immigration Station to form America's "Historic Trilogy," marking a significant era in American history. Immigrants from Europe were greeted by the Statue of Liberty, processed at Ellis Island, and boarded trains at the CRRNJ Terminal.

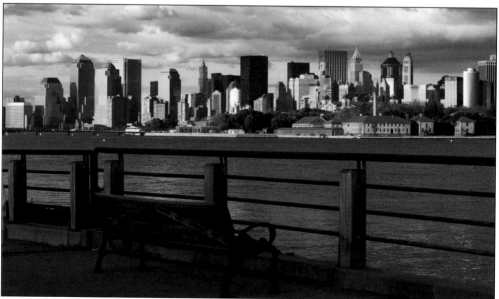

From this unobstructed view, the New York City skyline compliments Ellis Island's presence. Opened in 1892, the Immigration Station welcomed two-thirds of the 12 to 17 million immigrants who traveled to start their new lives via the CRRNJ Terminal, which was just a glance to the left if sitting on this LSP bench!

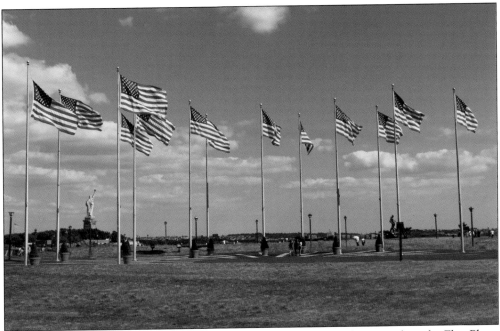

The southeastern portion of LSP contains a curving grassy mound surrounding the Flag Plaza. A total of 13 American flags, representing the 13 original colonies, fly from spring to fall. The site of many momentous events, most notably LSP's opening day ceremony, the Flag Plaza is a reverential reminder of shared freedom.

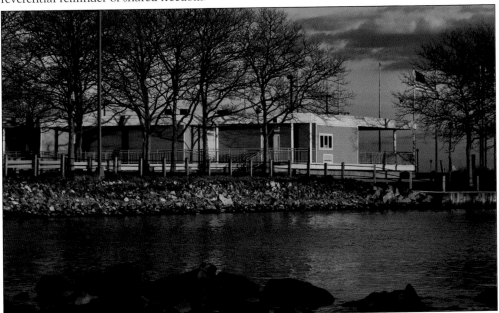

The Administrative Building was the first structure opened in LSP. It serves mainly as an information center, providing details on local and state attractions and scheduled historical and nature program offerings within the park. Since the destruction of the Nature Interpretive Center by Superstorm Sandy, the Administrative Building has temporarily absorbed the Nature Interpretive Center's services.

Two American flags rise from the North Flag Plaza marking the 10-acre section of LSP called Millennium Park. This expanse, blending west toward the Grove of Remembrance, contains planted beds, lawns, seating areas, and paved paths. Hundreds of purple alliums fill three long mounds forming the median Freedom Way Gardens. Audrey Zapp Drive, the age-old cobblestone road intersecting Freedom Way has three compacted layers of cobblestone "fill" acquired from ship ballast.

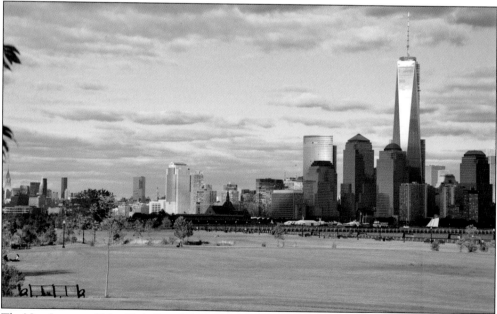

The New Jersey and New York City skylines seem to blend in this view from the former CRRNJ coal-processing site. The iconic Empire State Building's spire is on the extreme left, CRRNJ Terminal's rooftop tower is in the center, and on the right the Freedom Tower's spire rises to the clouds.

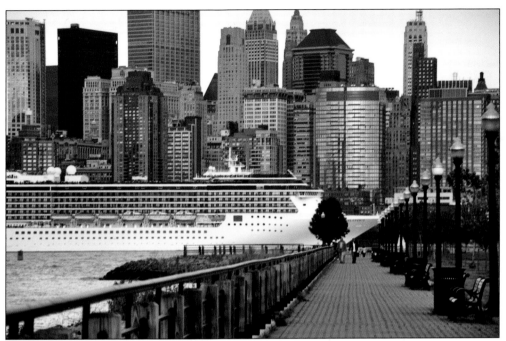

Cruise ships beginning their voyages from New York City piers are a common sight from all parts of LSP. Pictured are strollers enjoying the northern end's walkway, just east of the adjacent and active docks of Liberty Landing Marina. The marina is integrated with the LSP walkway without limiting access to the public.

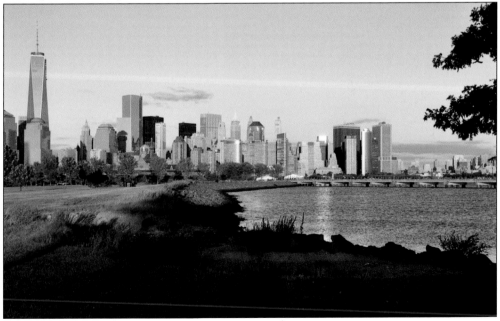

The North Cove formerly contained heavy piers extending into the harbor. The piers and docks, along with the other buildings abandoned after bankruptcy, were eventually demolished. The waterfront walkway bridge, extending across the riverfront inlet, now borders the North Cove. The CRRNJ Terminal's rooftop is visible behind the trees.

Cutting across Morris Pesin Drive, near the public boat launch's parking lot, there remains the only functioning rail track leading directly into LSP's southern end. A vestige from the railroad era, this active track currently serves the neighboring Daily News Plant, a privately owned company on Theodore Conrad Drive.

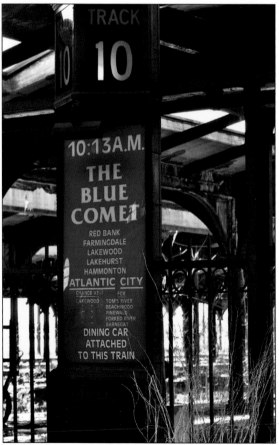

This is a replica of one of the numbered concourse gate signs. The terminal's Blue Comet Auditorium, designed to resemble the terminal as it looked 80 years earlier, was created in the 1990s as one of the ways the terminal was adapted for use as part of Liberty State Park.

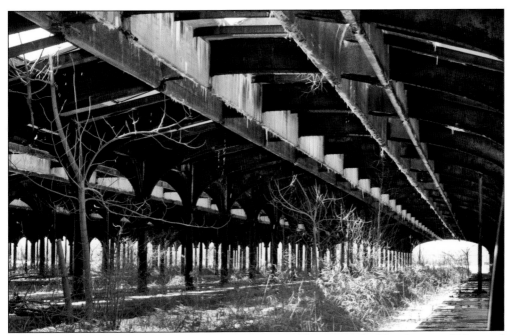

Saved from demolition, the CRRNJ Train Shed, pictured here, is in the New Jersey and National Register of Historic Places. Hundreds of trains per day departed or terminated under this shed's 7.5-acre roof that covered 20 tracks. It is the largest and one of the last great train sheds remaining in America.

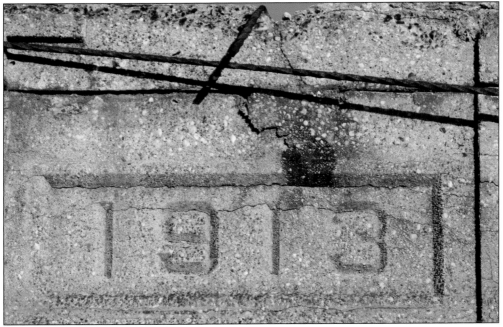

In 1913, the new Bush-type shed, designed by A. Lincoln Bush, replaced the 1889 gabled train sheds, which was the last of its type ever built. A sheltered loading and unloading area, the shed covers 330,000 square feet, over nine aisles and 20 tracks; it is the largest ever built. The shed remains standing but unrestored!

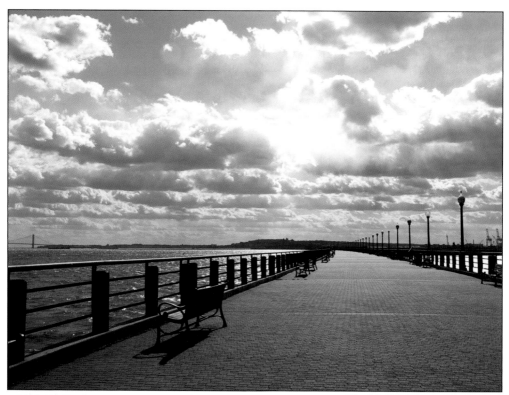

The Hudson River Waterfront Walkway is a 30-foot-wide pathway at the edge of the Hudson River extending over 18 miles from Bayonne to the George Washington Bridge. LSP shares a 1.5-mile north-to-south portion of the promenade. East-to-west portions have recreational access for fishing and boating.

The Liberty Science Center is visible from most areas of LSP. Its blue triangular tower and large dome have become another landmark guiding star. Located at LSP's northwestern end, the tower defines the park's boundaries and distance by the angle and position of whatever and how much of it is visible.

Cherry Tree Lane, formerly a state-of-the-art coal transferring station site, is located in the vicinity of the Nature Interpretive Center. After the massive coal station was demolished, a leftover mound became the highest point in the park. A winding pathway and plaza were created, and cherry trees, donated by FOLSP, followed.

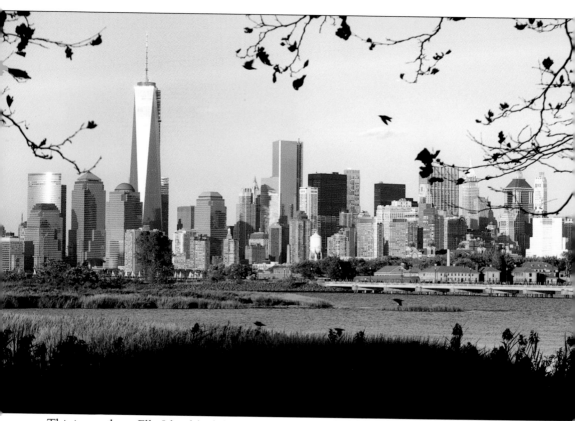

This image shows Ellis Island (right) behind the Waterfront Walkway bridge, which extends across LSP's southern cove; the completed Freedom Tower, located in the vicinity of the former World Trade Center's Twin Towers; and the southern end of the New York City skyline as viewed from the southeastern portion of the salt marsh.

Two

A Grassroots Movement

LSP owes its life to the spirit of activism. Morris Pesin was the spark that ignited the spirit of LSP. After a long and frustrating family outing through New York City to the Statue of Liberty, his eyes were drawn to the horrific sight of his Jersey City hometown shoreline. The decayed and rotting postindustrial era wasteland loomed as a ravaged landscape relinquished to fate. He immediately became angered and, at the same time, inspired.

It would take 18 years to transform what Morris Pesin's eyes had physically seen to what his mind had envisioned. The dramatic change was not accomplished alone. Joining the grassroots crusade were Ted Conrad, a nationally recognized architectural model builder who constructed a model of a tree-filled park that he and Morris Pesin would take when rallying support, and Audrey Zapp, a staunch environmentalist who lobbied tirelessly to secure Green Acres Program funding for the purchase of parklands. Along with Jersey City historian J. Owen Grundy, and civic, business, and religious leaders, all became a powerful force toward the creation of LSP, which finally opened in 1976.

The work continues to this day. Friends of Liberty State Park (FOLSP), formed in 1988, serves as the park's premier advocacy group. Among government officials instrumental in shaping the future of LSP were Richard Sullivan, Col. Jerry McCabe, Sen. Robert Menendez, and Gov. Christine Whitman. All were combined in spirit and purpose to create today's living legacy—LSP.

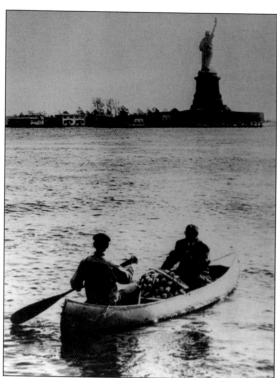

In 1961, Morris Pesin, the "father" of LSP, reenacted his eight-minute canoe ride to remind the public of the proximity of Jersey City's waterfront to Lady Liberty. He is pictured here, on the right, paddling with a reporter toward the Statue of Liberty with a wreath he placed at her base, proclaiming 75th birthday greetings! (Courtesy of the *Jersey Journal*/Landov.)

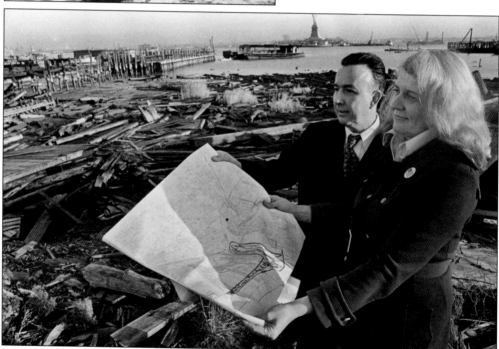

Audrey Zapp, standing with her husband, Warren, is shown examining a map of a future portion of LSP. Audrey Zapp was LSP commissioner, appointed by Gov. Christine Whitman. An environmental champion and advocate for using the state's Green Acres Program funds for LSP, Audrey's focus was on the recuperative powers of nature on urban people. (Courtesy of LSPHA.)

This is the original 1962 Statue of Liberty Causeway and Park Association poster. It lists the following founding members: Morris Pesin, chairman, and trustees Theodore Conrad, Vincent Ceretta, Walter McInerney, and Milton Gottlieb. The park model and poster remain protected by Ted Conrad's daughter Doris, alongside Conrad's other groundbreaking architectural models awaiting future display destinations.

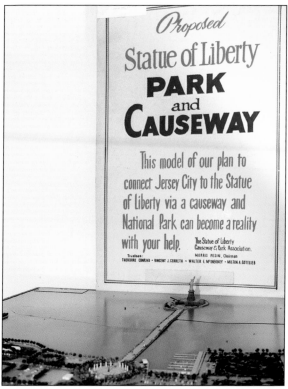

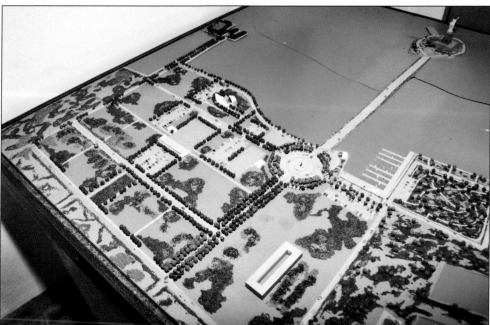

This foldable original model of LSP, created and financed by LSP advocate and renowned architectural model maker Ted Conrad, a pioneer in the use of Plexiglas and metal for models, was taken to Trenton to rally support from state officials for the creation of a park with a causeway to Liberty Island.

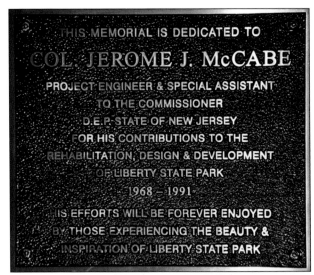

THIS MEMORIAL IS DEDICATED TO

COL. JEROME J. McCABE

PROJECT ENGINEER & SPECIAL ASSISTANT
TO THE COMMISSIONER
D.E.P. STATE OF NEW JERSEY
FOR HIS CONTRIBUTIONS TO THE
REHABILITATION, DESIGN & DEVELOPMENT
OF LIBERTY STATE PARK
1968 – 1991
HIS EFFORTS WILL BE FOREVER ENJOYED
BY THOSE EXPERIENCING THE BEAUTY &
INSPIRATION OF LIBERTY STATE PARK

Dedicated on September 15, 2009, Col. Jerome McCabe's memorial plaque hangs outside the CRRNJ Terminal's Blue Comet Auditorium. Working for the New Jersey Department of Environmental Protection as LSP's project engineer, he was instrumental in land acquisitions, rehabilitation, design, and development of LSP, including refurbishing the CRRNJ Terminal and construction of Liberty Walk.

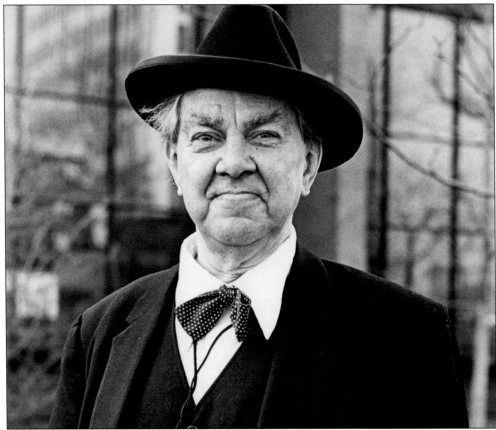

In 1982, Jersey City historian J. Owen Grundy wrote the following: "Liberty State Park was built with the people's money and belongs to the people. Now that we have recovered our heritage, we do not mean to stand mute while it is given away to 'private interests.' " The quote was considered one of the best statements made in connection with the need to protect LSP against commercialization and privatization. (Courtesy of LSPHA.)

John Tichenor, cofounder and first president of FOLSP, is shown speaking at the 2012 ribbon-cutting ceremony for the group picnic pavilions in Freedom Field. With Arisides Pappidas, John Tichenor cofounded the organization. A passionate devotee of a free and green public park, John Tichenor drives or walks through LSP every day, with his eyes alert to anything requiring communication with LSP's superintendent.

Morris Pesin, an independent Jersey City councilman from 1969 to 1977, championed many causes, including antidiscrimination, preservation, and mass transit issues. He once stated, "I'm against people who step on other people." Known as a man of integrity, he said, "I had to become a politician myself in order to combat them and their injustices."

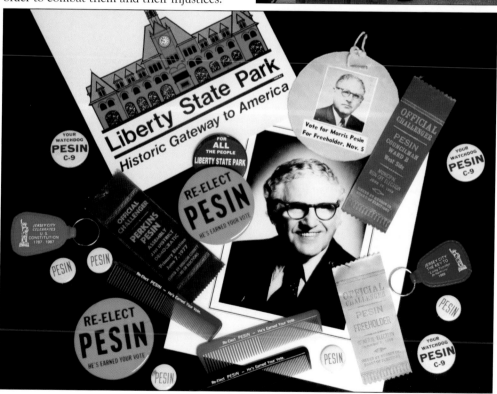

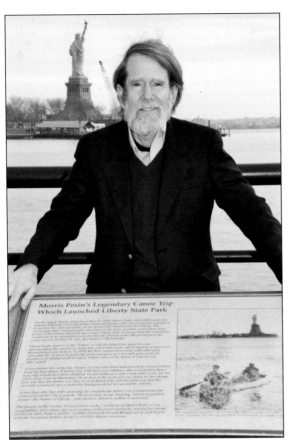

FOLSP president Sam Pesin stands by his father's waterfront walkway history sign. The sign's title reads, "Morris Pesin's Legendary Canoe Trip Which Launched Liberty State Park." The sign, located on the southern end of the walkway, details Morris Pesin's journey. The year 2013 marked the 55th anniversary of his father's canoe trip.

LSP's history includes the exceptional and inspiring efforts of its founders and local and statewide advocates. In repeated battles, grassroots "save the park coalitions" defeated many commercialization and privatization plans. Ever thankful for the public's unwavering involvement, FOLSP members consider themselves vigilant guardians of this free park behind Lady Liberty.

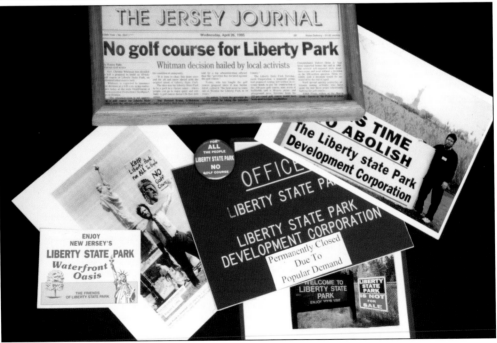

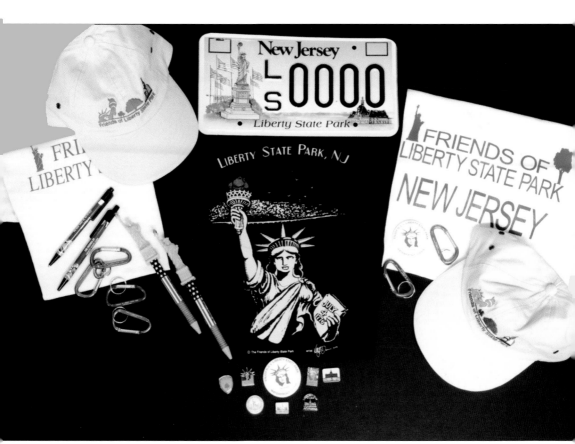

Shown above are some materials specially created to publicize and/or fundraise for LSP or FOLSP. A New Jersey "special interest" license plate supporting park projects is still an available popular item. Visitors are encouraged to consider FOLSP's caps, T-shirts, key chains, pens, lapel pins, and buttons . . . along with volunteering and/or membership.

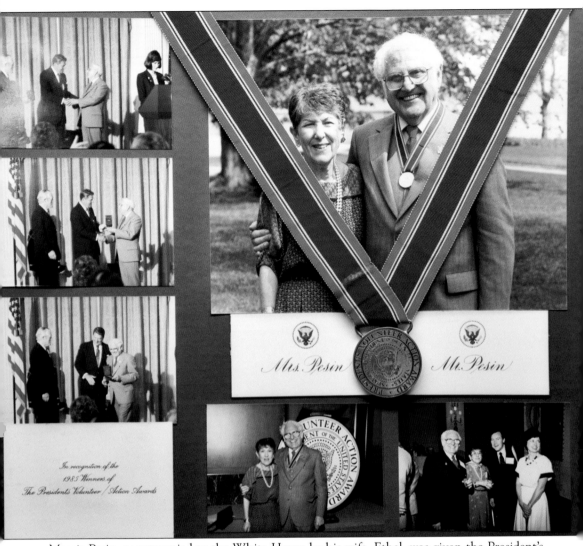

In recognition of the
1985 Winners of
The President's Volunteer / Action Awards

Mrs. Pesin Mr. Pesin

Morris Pesin, accompanied to the White House by his wife, Ethel, was given the President's Volunteer Action Award by Pres. Ronald Reagan on April 22, 1985. The program cited Pesin's efforts to establish LSP and his volunteer role in initiating a year-round calendar of cultural activities in Jersey City.

Three

NATURAL AREAS, WILDLIFE, AND GARDENS

Originally, wildlife and birds found sanctuary in Communipaw Cove's rich habitat, but as the cove was filled, survival challenges led them elsewhere. Two areas of LSP have been officially designated as protected natural habitats. One, the Richard J. Sullivan Natural Area, a 36-acre wildlife habitat, includes one of the few remaining tidal marshes of the Hudson River's estuary. Caven Point Beach offers mating grounds for horseshoe crabs, an adjacent bird sanctuary, and rocks for the occasional sun-basking seal. Local and migratory wildlife, including New Jersey's vulnerable yellow-crowned night heron, have rediscovered the much-needed vital habitat and breeding grounds. Rabbits, raccoons, muskrats, and over 240 species of birds are now included in LSP's growing lists of "visitors."

Gardens ranging from casual and rugged to semiformal show off LSP's unique aesthetic charms. These seasonally evolving gardens grew from a small traffic-island planting to 16 beautifully designed and cultivated plots. Though powerful winds, uneven soil quality, and exposure to unfriendly waterfront conditions make gardening in LSP a challenge, the ideals of native plant usage in each garden have been successfully nurtured to their optimum potential. The Garden Beautification Program is sponsored by FOLSP in partnership with LSP. Enthusiastic and committed volunteers from schools, churches, corporations, and local and statewide residents are the heart and soul of the garden program, planting and maintaining the garden plots. FOLSP has funded the planting of hundreds of trees and tens of thousands of bulbs, adding cheer and color to each spring. Piles upon piles of mulch, required to enrich and insulate plantings, is evidence of FOLSP's ongoing caring efforts to maintain this ambitious program. Volunteers hunched and kneeling in the earth, embraced by the grandeur of the New York City skyline and Lady Liberty, are a common sight. These valued volunteers play a vital role, ensuring LSP continues to flourish and attract visitors.

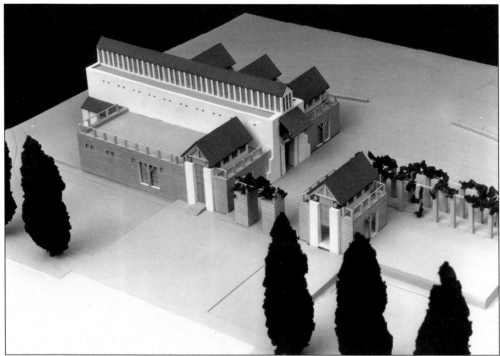

Pictured is the Nature Interpretive Center. This original model of the Nature Interpretive Center was designed by noted Princeton architect Michael Graves. The postmodern-style Nature Interpretive Center is a two-story stucco-glazed timber building. One approaches the Nature Interpretive Center through a colonnaded entrance that joins two pavilions. According to New Jersey journalist Gordon Bishop, the Nature Interpretive Center "resembles a Roman cathedral with a natural beauty" and "was inspired by the Madonna de Villa in Italy." The Nature Interpretive Center was designed and created as an environmental and historical education facility. Since Superstorm Sandy, the Nature Interpretive Center has been closed until reconstruction is completed. (Courtesy of LSPHA.)

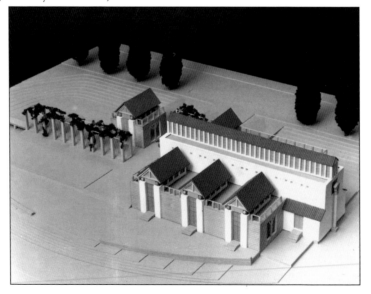

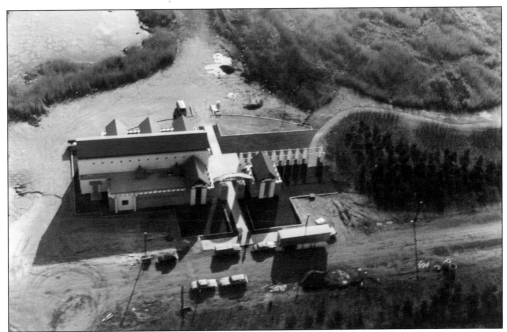

Final stages of construction of the Nature Interpretive Center show the grounds readied for completion of the planned system of pavilions and stone pathways. The self-guided winding nature path, shown leading off to the right, now offers descriptive signage and an opportunity to observe and experience the unique wildlife habitat. (Courtesy of LSPHA.)

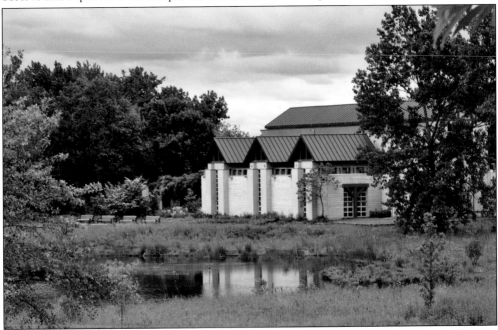

The surrounding setting of the Nature Interpretive Center is the park's 36-acre natural area, a tidal marsh of the Hudson River estuary. Architect Michael Graves not only designed the Nature Interpretive Center, but he also designed the birdhouses placed around the reclaimed wetlands. Decades later, the pond was added.

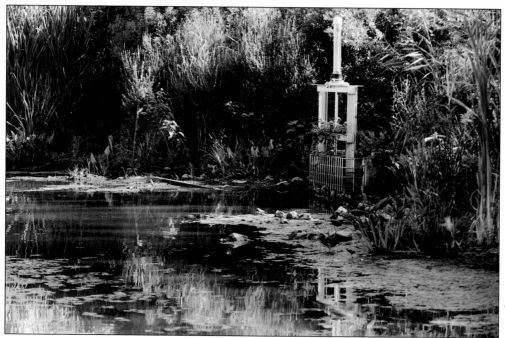

After the removal of soil with high concentrations of chromium, this site was turned into a diverse freshwater wetland. This photograph shows the outlet structure surrounded by native aquatic vegetation. All plants, whether on land or in or around water, photosynthesize, making them the major source of oxygen for aquatic animal life.

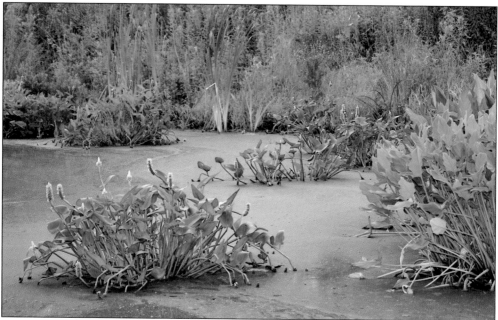

Aquatic plants in the Nature Interpretive Center's pond can be divided into four groups, algae, floating plants, submerged plants, and emergent plants. All groups of plants are encouraged within this area because they provide habitat and shelter for fish and other small organisms and are beneficial to local and migratory wildlife.

In 2005, the Richard J. Sullivan Natural Area was established in recognition of over 50 years of dedication to improving New Jersey's environment. This natural area's trail has illustrated signs describing what may be seen along the pathway. The trail eventually leads out to wide-open skies and a view of Lady Liberty.

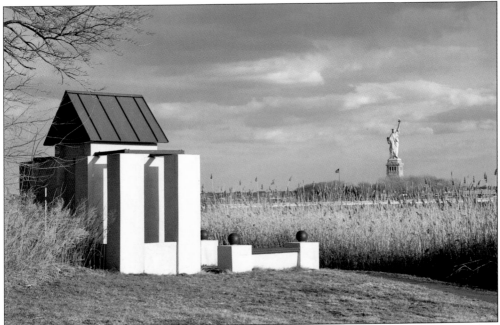

Located at the end of the Nature Interpretive Center, this gazebo is one of a system of several small pavilions designed by Nature Interpretive Center architect Michael Graves. Phragmites, a common invasive tall reed, forms a wall, blocking the salt marsh. Crushed by Superstorm Sandy, the phragmites have already recovered.

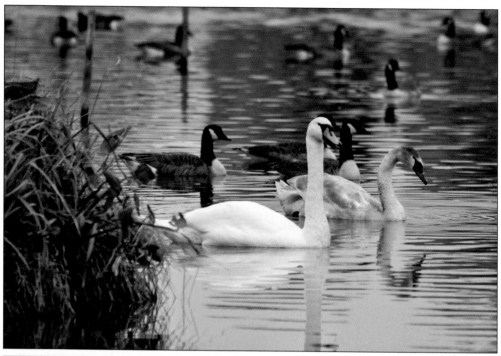

Mute swans frequently nest on the pier-like mound that extends from the Nature Interpretive Center pond shore into the water. They often use the same nest each year, restoring or rebuilding, especially after Superstorm Sandy, as needed. This parent swan wades besides its cygnet, sharing the Nature Interpretive Center pond with some Canadian geese.

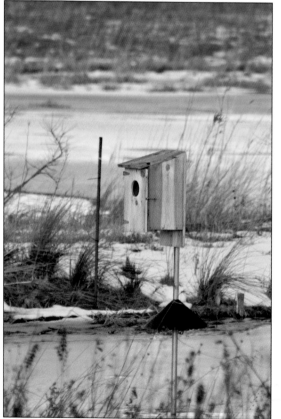

Birdhouses have been set about areas of LSP to encourage winged visitors to not only become residents, but also to return year after year. Keep one's eyes peeled for the return of red-winged blackbirds, warblers, tree swallows, and many of the other numerous species of birds that frequent the park.

This LSP waterfront sign describes mergansers that can be identified along the New York/New Jersey Harbor Estuary. Other diving ducks, such as buffleheads, ruddy ducks, and the common golden eye, arrive in LSP by late October. These signs, located throughout the park, provide visitors pertinent, onsite knowledge about LSP's history and nature.

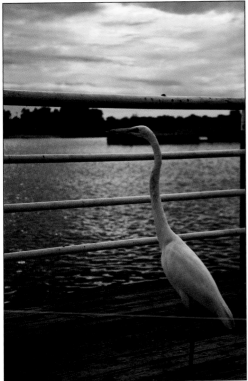

Great egrets, which are large yellow-billed, black-egged, all-white herons, are patrons of the southern portion of LSP's walkway. Close to the Caven Point Migratory Bird Habitat and Nesting Area, this section of the walkway has become a quick food resource for egrets lingering about for handouts from fisherman.

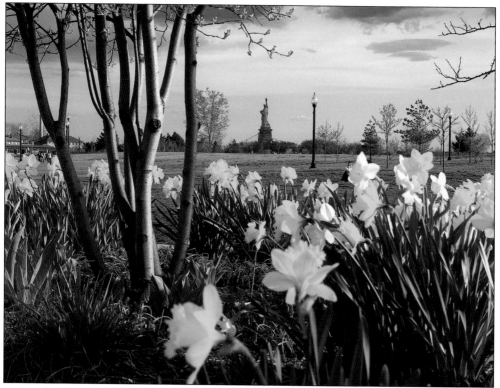

Spring daffodils, planted by volunteer gardeners, encircle ornamental fruit trees planted in the raised beds of LSP's playground gardens. Daylilies and wildflowers follow. Ash, hawthorn, and redbud surround benches near the beds. A row of evergreens marks the outside entrance to this scenic play and extending picnic area.

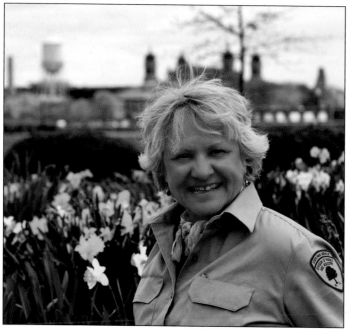

The FOLSP-sponsored Volunteer Gardening Program takes place every Saturday and during the week, as prearranged by Michel Cuillerier, FOLSP's garden program corporate liaison. LSP gardener Rosemarie de Wakefield, pictured at left, is dubbed "the Garden Angel" by FOLSP; she leads experienced and inexperienced volunteers and groups to help create and maintain the varied planting beds throughout the park.

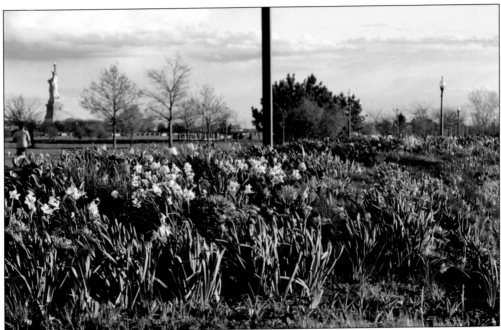

One of the most stunning garden areas greeting visitors at the intersection of Freedom Way and Audrey Zapp Drive is the Freedom Way Gardens. A traffic-island garden constructed of three long mounds, with a base of symmetrical ornamental grasses, form an aesthetically breezy background for seasonally changing bulbs and perennials.

Gladys Vasques's garden began with her continuous flower bulb donations in the 1990s. Former LSP superintendent Steve Ellis allowed Gladys to "adopt" a traffic-island garden on the southern end of Freedom Way. With assistance from Gina Provenzano, a Nature Interpretive Center naturalist and LSP staff, Gladys's Garden now encompasses the entire corner of Freedom Way! She continues to personally tend and fund the plantings in this garden.

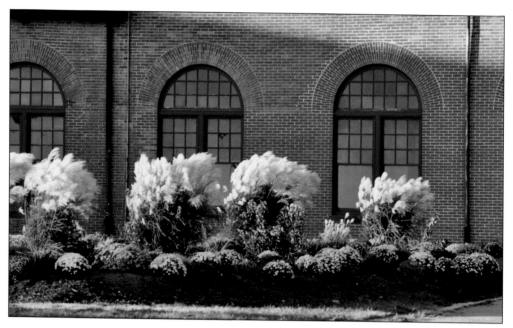

Mounds of mums fill the 18 plots bordering the southern edge of the terminal shed. A landscape full of detail and movement, the grasses dance from side to side about a stunning base of gold, orange, and yellow, reminding visitors of this garden's windy riverside location. Extending around the back, this same garden shares its autumnal colors with the complementary redbrick and golden-cream-colored brick of Ellis Island. In springtime, these "Riverside Gardens" are transformed into a rainbow, as clusters of multicolored bulbs surround the swirling and swaying ornamental grasses, becoming a delight-filled frame for this same spectacular view.

This modest signpost indicating the Migratory Bird Habitat and Nesting Area also marks the Caven Point gateway entrance to the beach. Closed to the public from March 1 to September 30 to provide an undisturbed breeding and nesting habitat for migratory and resident bird populations, this area has a raised modular pathway for off-season walks.

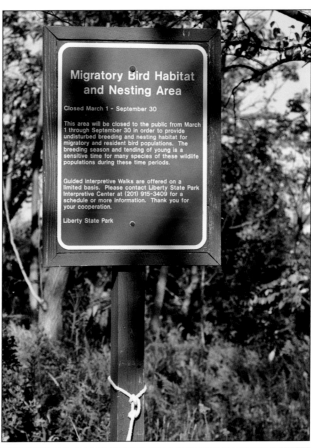

Caven Point Beach, a curving tract of gray-white sand, is reminiscent of Communipaw Cove's original shoreline. Spent oyster and mussel shells, baby sea turtles, red beard sponges, and horseshoe crabs provide an invaluable food source for the many migratory birds flying through the harbor on their journeys north and south.

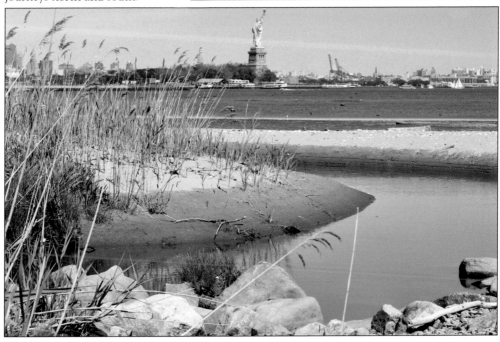

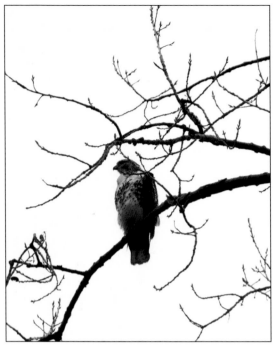

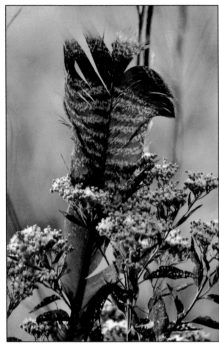

At left, a red-tailed hawk watches for a meal. Raptors are birds of prey whose preservation contributed to saving the park from developers. The US Fish and Wildlife, citizens, and New Jersey Audubon Society helped preserve LSP by recognizing the important role of raptors in LSP. At right, a pheasant feather appears anchored in a stem of Queen Anne's lace, which is also called wild carrot. This bird is part of a fluctuating population, including wild turkeys, ring-necked pheasant, and guinea hens. All of these birds were highly hunted in the area during the first half of the 1900s. (Left, photograph by LSP deputy superintendent Jonathan Luk.)

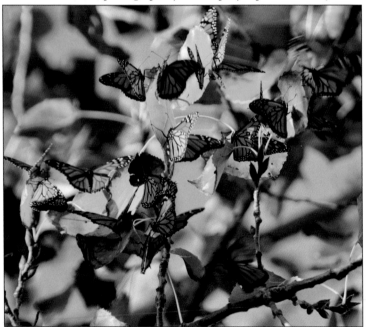

Thousands of monarch butterflies can be found occupying a single overhang, field, or tree in LSP. Monarchs lay their eggs exclusively on milkweed. The park's abundant supply is key to their continuing life cycle, especially noticeable around the Nature Interpretive Center where lots of milkweed has been purposefully planted!

During low tide, the shallow waters of the Caven Point Migratory Bird Habitat and Nesting Area become a vast mudflat. In this photograph, the area deceptively appears free of birds. Marine fare caught in puddles make this time of day an easy buffet for hidden skimmers, herons, and egrets.

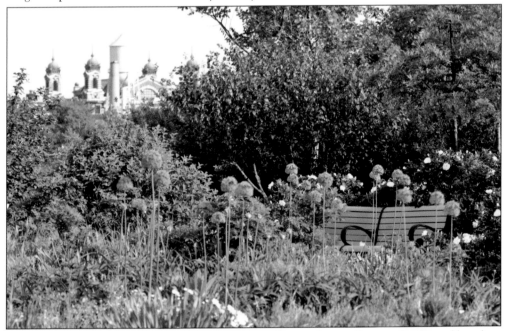

Generous groupings of plants, trees, and flowers overflow in this small maze of paths and benches. This garden was specifically planted to attract butterflies and hummingbirds. As one sits for a moment to gaze across to Ellis Island, he or she may also catch a glimpse of a hummingbird sipping nectar.

This circular plaza is the first stopping point along Cherry Tree Lane. Offering a peek at the river and features of the Green Park and Green Ring to the north, this cozy spot provides walkers a westward view of Freedom Way. The flowers, destroyed by Superstorm Sandy, have since been replanted.

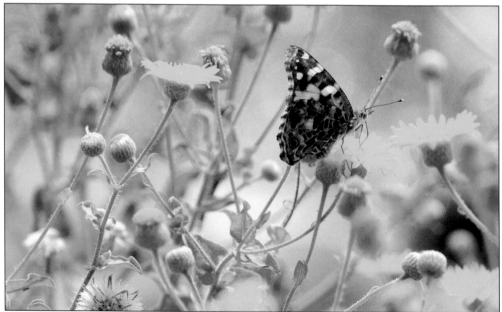

The excitement and joy of natural discovery allows LSP visitors to experience the wonder-filled metamorphosis from larvae to butterfly. Nature Interpretive Center naturalists offer easy ways to identify and explore every aspect of the life cycles of these marvelous insects, allowing a chance to become amateur entomologists to all who participate!

In several large and small plots scattered casually around LSP's master garden, a semicircular garden protected by a small berm and planted by Rutgers University Master Gardeners, a dense collection of colorful wildflowers is planted around the base of trees, pathway edges, and open fields.

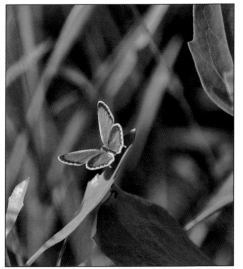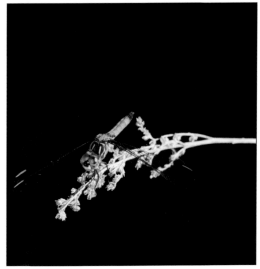

The Nature Interpretive Center's pond, as well as the surrounding wildflower field, is host to all varieties of butterflies, moths, and flying insects. Besides pesky gnats and mosquitos, beautiful species like the swallowtail butterfly or this smaller blue butterfly (left) can be enjoyed by both the hobbyist and casual visitor. This male blue dasher dragonfly (right) is usually found around wetlands because their larvae, known as nymphs, are aquatic. Look for zebra dragonflies and common whitetail dragonflies about the pond. All of these colorful insects add to the serene pastoral scene behind the Nature Interpretive Center and are subjects included in LSP's Nature Interpretative Center programs.

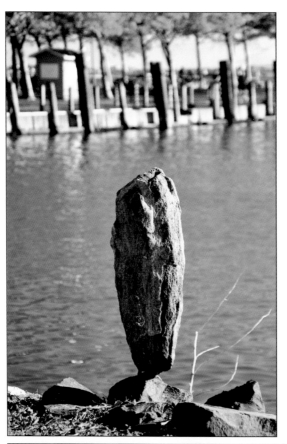

Several times, stones over two feet tall, obviously requiring a strong arm to move, were vertically posed in seemingly precarious positions. Maybe it was someone's fascination with Stonehenge or the challenge of setting one large rock in a dubious position, but each time, the stones remained standing for almost one year!

Sculptor Charles Simonds constructed LSP's hidden castle in 1982. Sponsored by the State Art in Public Places program, Simonds created this miniature city, "Left Turns," which was the original name of the project, and two more, each hidden in LSP's tall grasses. The other two pieces of "living art" were reclaimed by nature.

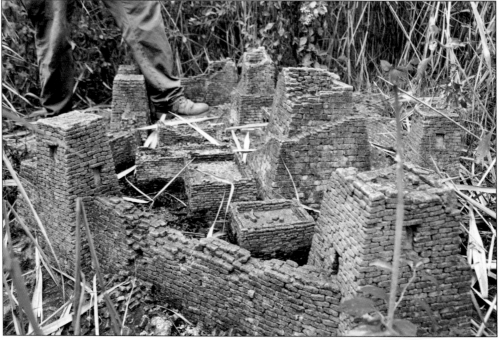

Four

TRAGEDIES, MONUMENTS, AND MEMORIALS

When considering natural catastrophes and tragic events affecting LSP, Superstorm Sandy and the September 11, 2001, terrorist attack on New York City's World Trade Center come immediately to mind. Thousands were brought to LSP from Manhattan and treated after 9/11. The terminal became New Jersey's Command Center and Family Assistant/Crisis Center, aiding victims' families with services, including critical information, death certificates, counseling, and financial support. Sandy's record storm surge brought seawater 1,200 feet inland, flooding park buildings, damaging walkways, benches, light poles, and other facilities. But these were not the first incidents of destruction. Today, few know anything about Black Tom—the largest act of sabotage on American soil. Black Tom Island, a small island munitions depot, was located in the vicinity of today's LSP Administration Building. On July 30, 1916, Black Tom Island was demolished in a blast that would have measured 5.5 on today's Richter scale. It was 30 times greater than the collapse of the World Trade Center's North Tower! The 2:08 a.m. blast detonated an estimated 2,000 tons of munitions and was felt as far away as Baltimore! The Statue of Liberty, at the explosion's epicenter, was scarred by the downpour of fiery steel shards. Its torch remains closed to the public. Marked today by a plaque in LSP's southeastern corner, the blast site lies less than two miles from where the Twin Towers were brought down by terrorist hijackers on 9/11.

With each devastating event, people are reminded of the deep and lasting closeness shared by individuals, the nation, and the world community.

LSP has memorialized significant people and events of historical importance in varied visual monuments and memorials—lasting tributes honoring the life contributions and sacrifices of others.

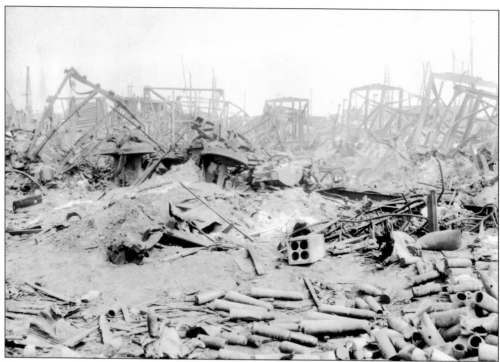

Pictured are the debris-strewn remains of Black Tom's damage after the well-planned set of synchronized explosions meant to stop American manufacturers from supplying arms shipments to Germany's enemies were detonated. The evening before, barges and freight cars were reportedly filled with over two million pounds of ammunition waiting to be shipped overseas. Barrels of black powder, TNT, and ammunition continued to "cook off" through the day, leaving 87 cars of spent shells, torn away earth, and $20 million—in 1916 dollars—in estimated monetary damage. Only seven people were killed, but the devastation rippled throughout America. (Courtesy of LSPHA.)

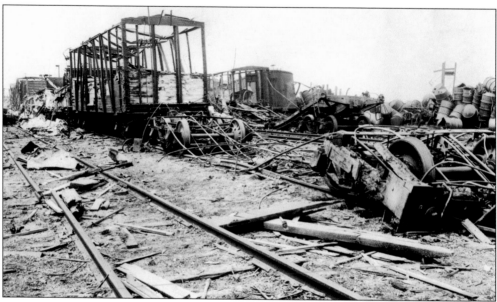

An unmarked tree planted by former LSP superintendent Josh Osowski in honor of Ethel Pesin's 90th birthday sits among the line of trees at the eastern end of Audrey Zapp Drive. Characteristic of Ethel Pesin's energetic spirit and constant support of LSP, the tree stands as a "living tribute" to her life.

This southern section of Liberty Walk was barely three years old when Superstorm Sandy's 2012 tidal surge ripped away its pavers and major chunks of the rocky bulkhead. Representing one of many rebuilding milestones, it has since been thoroughly restored to its former condition, barely indistinguishable from this original "pre-Sandy" image!

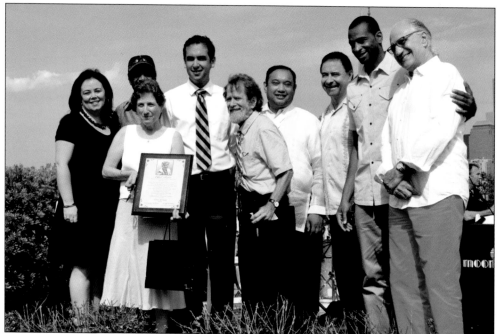

Shown above, Jersey City mayor Steven Fulop, on July 21, 2013, presented a plaque to Ethel Pesin's children, Sam and Judy, at a Summerfest concert. This tribute to the late Ethel Pesin celebrated her lifetime of service and advocacy on behalf of cultural affairs, free entertainment, and open space. Pictured are, from left to right, (first row) Judy Pesin; Jersey City mayor Steven Fulop; and Sam Pesin, FOLSP president; (second row) Maryanne Kelleher, director of Jersey City Cultural Affairs; Cliff Perkins, special events coordinator of Jersey City Cultural Affairs; Jersey City Council president Rolando Lavarro Jr.; Hudson County freeholder E. Junior Maldonado; director Ryan Strother of Jersey City Department of Recreation; and Louis Borriello, husband of Judy Pesin. Seen below, the Jersey Avenue footbridge, leading from Jersey Avenue into LSP, was named in honor of Ethel Pesin. Superstorm Sandy destroyed the former footbridge.

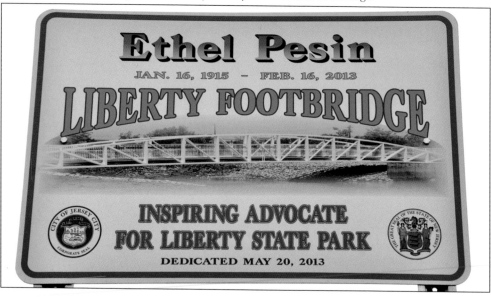

The ashes of Audrey Zapp, the gentle fighting lioness lovingly referred to as LSP's "Godmother," were sprinkled about this memorial tree by her son Rennie Zapp. The following year, flowers planted by volunteers and an attached spinning yellow daffodil prompted new visitors to wonder about this "distinctly" decorated tree.

Rennie Zapp commemorated his mother's devotion to LSP with memorabilia and a slide presentation that included former mayor Thomas F.X. Smith and Warren Zapp raising Audrey Zapp's namesake park sign. "My mother was a passionate advocate," he said, "always making sure the rights of people and nature were represented."

Superstorm Sandy's winds and tidal surge on October 29, 2012, closed all LSP to the public. Entrances had 24-hour security. As cleanup and repairs continued over the months, protective fencing came down. Some of the park's infrastructure has yet to fully recuperate. Estimated damages to LSP are over $20 million.

The shady picnic area at LSP's southern end lost many of its trees and picnic tables. The playground's slides and climbing equipment were ripped from their anchors and crushed together in the mangle of uprooted trees. Sandy winds took down over 100 trees and critically damaged dozens of others.

Supt. Robert Rodriguez (left) takes Tom Pfister (center) and Sam Pesin (right) of FOLSP on a review of Sandy's damage after 400 volunteers helped begin the cleanup of what would be 100 tons of river and land debris. The terminal and Nature Interpretive Center were gutted due to five feet of water damage.

A third of the pavers were blown away from the 1.5-mile-long Liberty Walk promenade. Most benches were lost. Some were found wrapped around the iron railings. The Jersey Avenue footbridge was pushed 30 feet from its location. The marina ferry docks and public boat launch were wrecked. (Courtesy of LSPHA.)

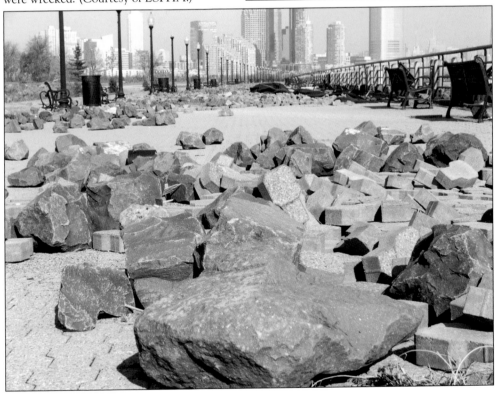

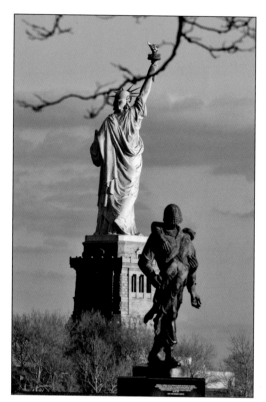

The *Liberation Monument*, strategically located in LSP's South Overlook Field, forms a "topological triad" that includes the Statue of Liberty and Ellis Island, recognizing the Holocaust as a counterpoint in contrast with American ideals of democracy. An overlooked feature is both the American soldier and Holocaust victim share a shoulder.

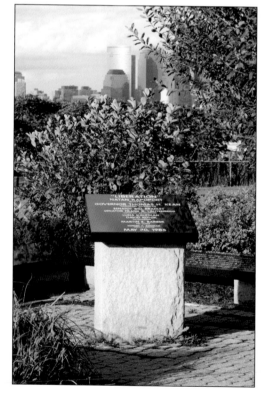

The state's 1983 dedication resolution of Natan Rapoport's *Liberation Monument*—a World War II concentration camp survivor carried to freedom by an American soldier—noted, "Our service members fought, not to conquer or to be aggressors, but rather to rescue and restore freedom to those persecuted and oppressed by the fascist powers."

Gino Giannetti's *The Sail of Columbus* commemorates the 500th anniversary of Christopher Columbus's journey to America. The monument serves as a reminder of the significant role New Jersey and New York City played in America's immigration history. The front depicts Columbus at the helm. The waterfront side depicts the explorer's travels.

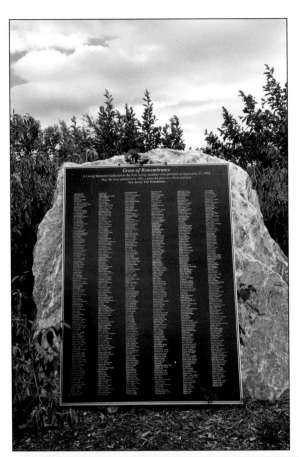

The Grove of Remembrance, once a 10.8-acre brownfield along Zapp Drive, is a memorial honoring the 691 residents of New Jersey who lost their lives during the September 11, 2001, terrorist attacks. Walkways link at the Memorial Circle where a bronze plaque with victims' names is mounted on a large pink marble stone.

The twin blue beams of "Tribute in Light" is the backdrop for an annual 9/11 memorial fire department and emergency services photograph shoot. The event, started in 2007 by Ed Gray and Bill Tompkins, honors those who selflessly served during 9/11. Pictured is Jersey City's Group B, Engine No. 7 ("Rolling Thunder"), Ladder No. 3. (Photograph by Ed Grey. Permission Jersey City Fire Department.)

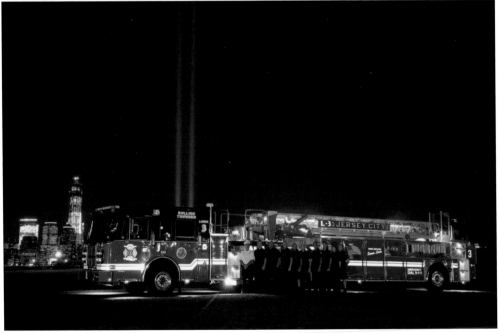

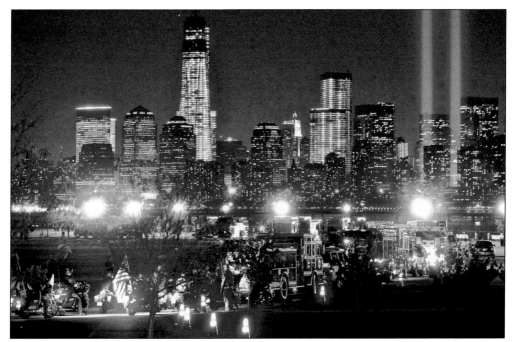

The annual 9/11 photograph shoot has grown from 10 trucks to well over 100, including those from surrounding states. The continuous flow of vehicles entering LSP's Green Ring inspires a renewed respect for the energy and dedication of all who remain waiting to help at a moment's notice.

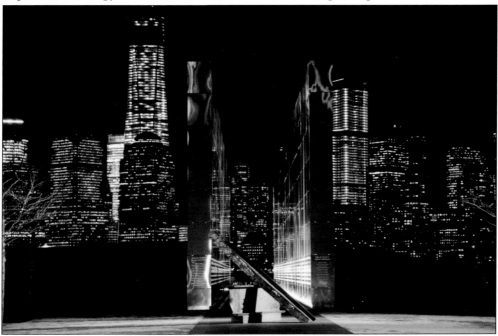

Empty Sky, a memorial to the victims of September 11, 2001, attacks on New York City's World Trade Center, was dedicated 10 years later on September 10, 2011. Designed by Frederic Schwartz, parallel brushed-stainless steel walls, engraved with the names of the victims, are oriented to face the former Twin Towers.

Positioned behind LSP's northwestern end, Jersey City Medical Center, a designated regional trauma center receiving many awards and distinctions, was involved in the coordination of major incidents, including the 1993 and 2001 World Trade Center attacks and Hurricanes Irene and Sandy. It has also served during other large-scale LSP concerts and events.

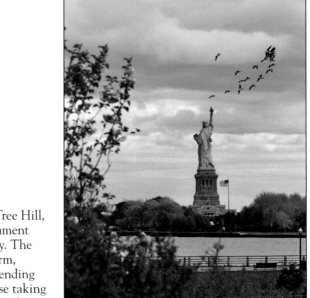

Viewed from the bottom of Cherry Tree Hill, the Statue of Liberty National Monument stands nobly in the cloud-covered sky. The defining quiet of an approaching storm, the waterfront promenade and flag tending guard, and the sight of a flock of geese taking flight subtly magnifies the sense of freedom.

Five

RECREATION AND
SPECIAL EVENTS

Ranging from the New Jersey Symphony Orchestra to the three-day All Points West Music and Arts Festival, LSP's grand lawns have been host to many outstanding events. Summerfest, a Jersey City–sponsored program, has become the longest-running free concert series in New Jersey. Jersey City's City Spirit Cultural Arts, Earth Day, and City of Water Day Festivals and LSP's Haunted Terminal Tour have entertained and educated the public. LSP is a favored location for fundraising runs, walks, and even a sludgy obstacle-ridden mud run! Red Bull Air Race chose LSP as the site for its world-class competition. Veuve Cliquot Polo Classic showcased the sport of polo in support of LSP's reconstruction after Superstorm Sandy. LSP is also a desired location for movie and commercial shoots. Bicyclists, walkers, joggers, and rollerbladers take advantage of the miles of scenic walkways and trails. LSP's playgrounds and picnic areas delight children and families. LSP is considered New Jersey's and New York's best kite-flying option. Bird watchers have become ardent patrons of the park's expanding bird species list. Fishermen are a constant park fixture, always ready to show off their buckets of blue crabs or dangling catch of the day! Boaters and kayakers are lured by the spectacular views and challenge of their sport at this Hudson River locale. Hop on a ferry and visit the Statue of Liberty and Ellis Island, catch a water taxi to New York City, or participate in one of LSP's nature or history programs. But more than recreational amenities and events, there is a heartening and powerful undercurrent of friendliness. Whether exchanging a silent smiling nod or sharing the burst of glee when a first-time visitor experiences the sight of the Statue of Liberty, Ellis Island, or the New York City skyline, there can be no denying that the biggest recreation here is smiling.

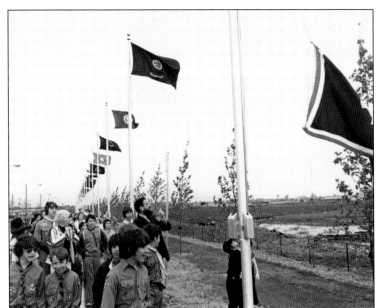

On LSP's opening day, June 14, 1976, Boy Scouts and Girl Scouts, working together with park rangers, raised the flags for the first time along Morris Pesin Drive. The honored group raised each state's flag in order of statehood starting with Delaware and ending with Hawaii. (Courtesy of LSPHA.)

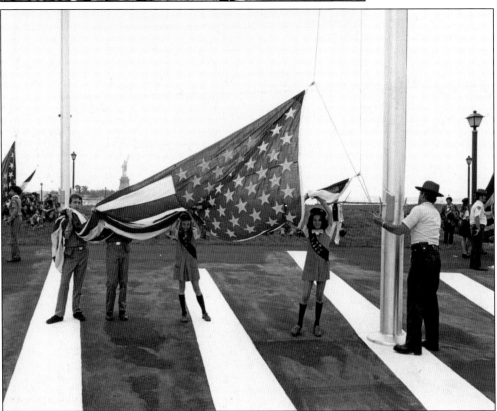

Boy Scouts and Girl Scouts, aided by park rangers, continued the opening day ceremonies traveling to the South Overlook Lawn's Flag Plaza. There, they proudly raised 13 state flags representing the original 13 colonies and the founding of the nation, generating cheers and smiles from all. (Courtesy of LSPHA.)

In 2011, a ceremony commemorating the 26th anniversary of the Lady Liberty Marines was held in the South Overlook Flag Plaza. Over a quarter of a century ago, after a 610-mile fundraising relay marathon to raise money to help restore Lady Liberty, the greatest symbol of freedom and democracy, the Lady Liberty Marines presented a donation check to Morris Pesin at LSP on the eve of being sent to the Middle East. Some of the original marathon runners were present at the ceremony.

In this 1968 shot, the CRRNJ Concourse, the area between the head house and the gates to the trains, is shown being used in filming a portion of the movie *Funny Girl*. (The cameraman is atop a ladder on the bottom left.) In the movie, Barbara Streisand (not shown here) runs across and sings in this room—years after the trains stopped running. (Courtesy of LSPHA)

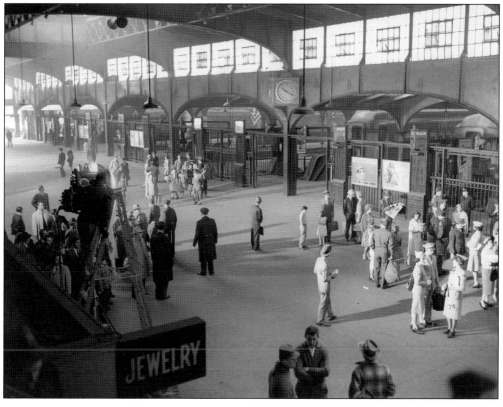

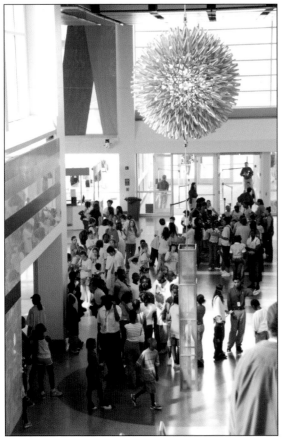

Built on the site of the former CRRNJ double roundhouse, Liberty Science Center opened in 1993. This privately run family museum has three floors offering 12 galleries of interactive exhibits, including a mini-aquarium, a mini-zoo with monkeys, free science shows and demonstrations, and the largest IMAX Dome Theater in the country. Hoberman Sphere, the largest existing aluminum and stainless steel isokinetic structure, hangs near the Liberty Science Center entrance welcoming visitors to the spacious building by opening and closing on a 20-minute cycle. Fully expanded, it is 18 feet in diameter and weighs 700 pounds. (Courtesy of Liberty Science Center.)

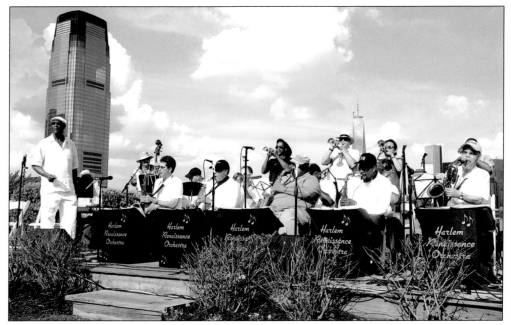

The Harlem Renaissance Orchestra entertained the Summerfest crowd with big band–era music. Jersey City presents a variety of music genres, including rhythm and blues, jazz, pop, and rock and roll oldies at the free Summerfest series in the public gardens behind Liberty House Restaurant during July and August.

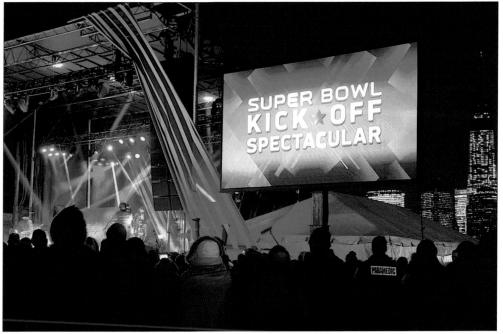

During one of the coldest recorded winters, the 2014 Super Bowl Kickoff Spectacular at LSP featured an outdoor concert by Daughtry, the Goo Goo Dolls, and The Fray, capped off by a pyrotechnic display launching fireworks 1,000 feet high from two barges on the Hudson. The event marked the official start of a week of NFL-sponsored events celebrating Super Bowl LXVIII.

Liberty House Restaurant, on the northern end of LSP, offers panoramic views of the New York City skyline, Lady Liberty, and Ellis Island, hence its "view with a room" catchphrase. Offering a la carte and special event space, the Liberty House Restaurant opened in 2002. It features both indoor and outdoor dining, a magnificent public garden complete with a life-size chess set, fire pits, outdoor bar, and Miami-style cabanas. (Courtesy of LHR.)

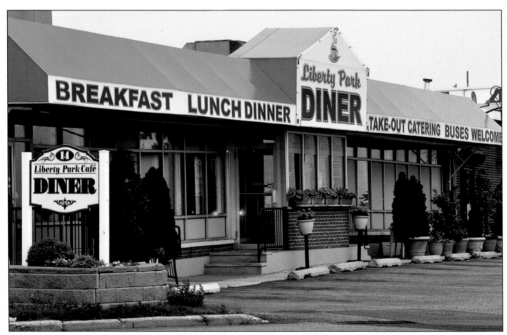

Liberty Park Café Diner, tucked away at the intersection of Burma Road and Morris Pesin Drive, offers affordable food served in a fun, family-oriented, casual atmosphere. The diner's popular life-size replica of the Statue of Liberty serves as a photograph friendly model for visitor's who stop at this welcoming destination.

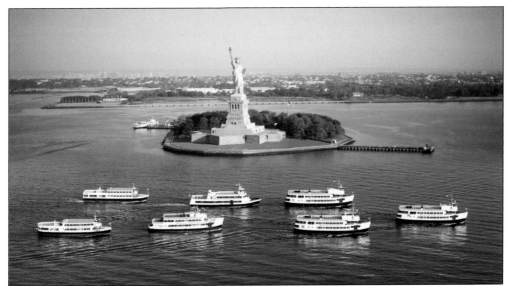

In 1977, the first ferry from New Jersey to the Statue of Liberty began operating from LSP. Since 2008, Statue Cruises has been the authorized ferry service concessionaire to the Statue of Liberty National Monument and Ellis Island. Statue Cruises is the exclusive provider of transportation, tickets, tours, and private events to the Statue of Liberty and Ellis Island, with daily departures from Liberty State Park. (Courtesy of Statue Cruises.)

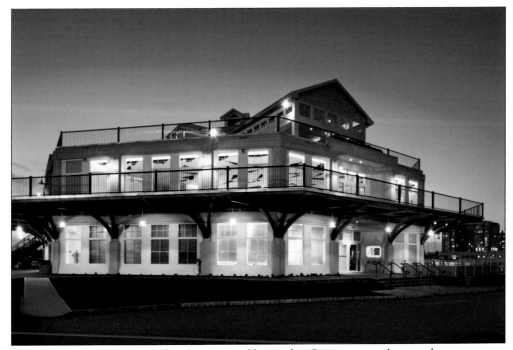

Maritime Parc's executive chef and co-owner Christopher Siversen provides a modern restaurant and multifloor event space with seasonally and locally inspired menus that exemplify the special nature of its waterfront location. Maritime Parc is critically acclaimed and consistently rated one of the top restaurants in New Jersey. (Courtesy of Maritime Parc.)

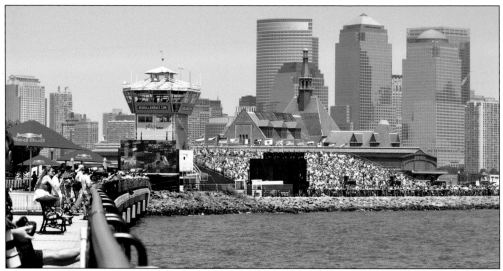

In 2010, viewers at LSP watched in awe as Red Bull Air Race Championship pilots flew through a technical and tight track at up to 350 kilometers per hour at only 15 meters above the water's surface. The planes passed tight air gates in different maneuvers while considering wind-speed, weather, Lady Liberty, and Ellis Island! (Red Bull's marks are registered trademarks of Red Bull GmbH.)

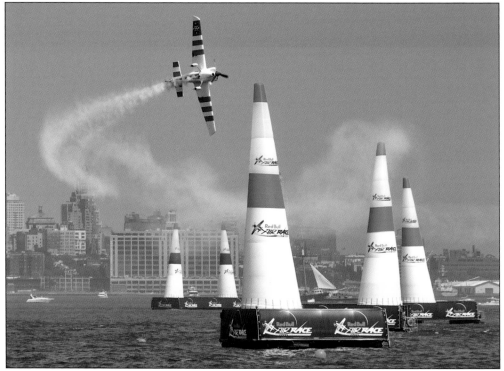

There were only a few meters between the wings and the pylons. At such high speeds, the pilots operated in dimensions of millimeters. Flying skillfully, Paul Bonhomme took first place in his red-and-white plane at the 2010 Red Bull Air Race World Championship over the Hudson River at Liberty State Park. (Red Bull's marks are registered trademarks of Red Bull GmbH.)

Kite flyers from all over come to LSP and are challenged by the sometimes fierce and overpowering winds coursing through the park's great fields. Kite club stunt championships, master-level sport-kite competition teams, and synchronized flyers have found LSP a favorite sky arena. LSP has been considered by kite organizations as New Jersey's and New York's best kite-flying option.

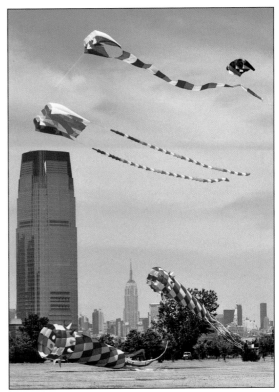

With the development of Liberty State Park came a renaissance of the entire Jersey City waterfront area. Land, with decaying buildings, overgrown tracks, and piles of debris, was transformed into a modern urban state park that invited visitors from everywhere to relax and enjoy the park's vistas in their own individual way.

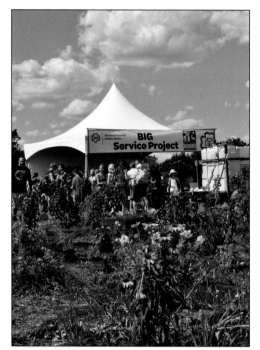
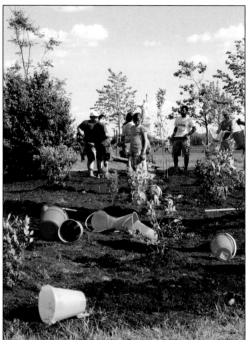

About 5,000 Girl Scouts from around the country joined forces at LSP to celebrate their 100th anniversary with their BIG (Believe In Girls) Service Project, seen at left above. The National Wildlife Federation, LSP gardener Maria DeWakefield, and park staff supervised as Scouts cleared and planted over 600 native plants and shrubs in flower beds. The daylong Girl Scout BIG Service Project event featured over 100 activities, including cooking and tech pavilions, crafts, a soccer clinic, hip-hop classes, an obstacle course, astronomy experiences, bounce houses, and rock wall climbing. After creating a large new garden plot in LSP's Green Field, pictured at right above, the event culminated with concerts and fireworks.

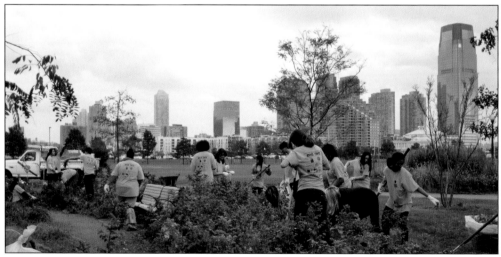

LSP was one of many sponsors of Jersey City Parks Coalition's annual Big Dig. Part of National Make a Difference Day, this award-winning collaborative project has proven the positive impact of volunteerism on a community. The Big Dig has already seen nearly 20,000 flower bulbs planted across the city. (Courtesy of Laura Scholar.)

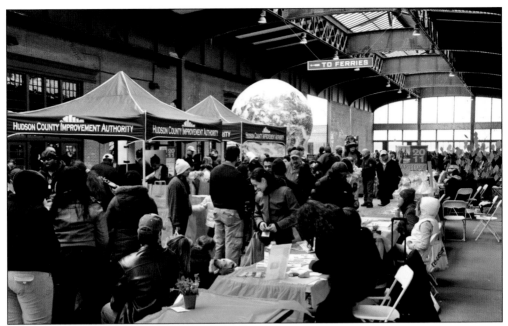

Each April, LSP hosts an Earth Day celebration. Sponsored by the Hudson County Improvement Authority, the event inspires consciousness for the Earth's environment with over 100 vendors, 70 exhibitors with eco-friendly information, entertainment, free rides and activities, and a 5K run. Superstorm Sandy caused the event to be moved outside the damaged terminal.

The terminal's shed gates hold written pledges to be mindful, appreciative, and actively diligent in an individual's environmental responsibilities. Earth Day promises ranged from not littering, not wasting food or water, and recycling to shutting off the lights, television, and computer when not in use.

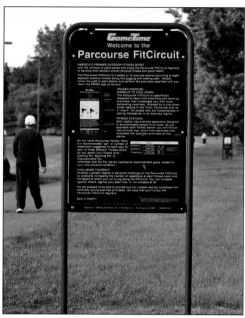

Earth Day is a fun-packed festival experienced from any height! Held annually for the past 10 years, the fair, which continues to bring the community together to promote recycling and environmental education, draws 7,500 area residents each year. This roaming tree and her companion were a popular awareness-raising couple! The name Parcourse implies there is a "par" or number of repetitions suggested for three different "fitness levels"—starting par, sporting par, or championship par. Each Parcourse FitCircuit station sign has exercise apparatus matching the challenge. Par merely represents recommended goals based on one's own physical condition.

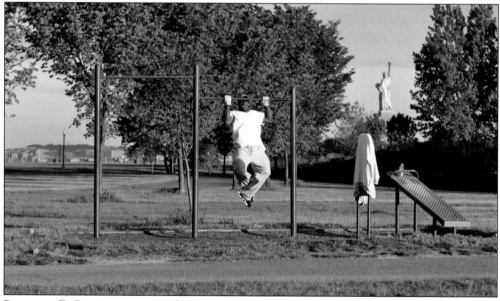

Parcourse FitCircuit is a series of 15 exercise events at eight separate stations along Freedom Way with apparatus designed to accommodate people of all sizes and fitness levels. As exercisers approach each fitness station, they will find an instructional sign, fully describing and illustrating specified exercises at that station.

The Original Mud Run combined a 6.2-mile trek with hard core military obstacles designed to test strength, stamina, mental grit, and camaraderie! One of the many fundraising events held at LSP, this innovative course encompassed the entire park landscape and raised over $25,000 for the Multiple Sclerosis Society.

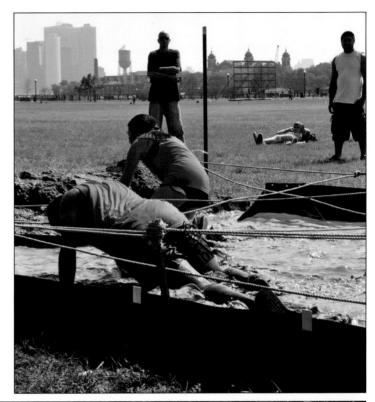

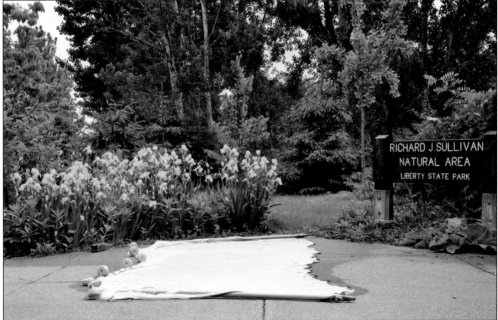

During seining, a net hangs vertically in the water with its top floats and bottom weights drawn together to encircle any water critters. This large Nature Interpretive Center seining net has been spread on the ground for drying after estuary explorations are over until the next exciting and hopefully revealing expedition!

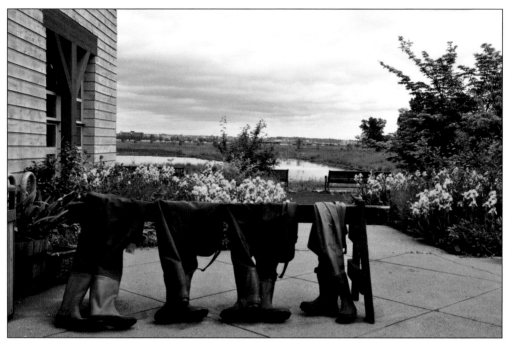

Chest waders donned for an educational exploration of the Hudson River Estuary are hung out to dry after a hands-on investigation of the life in and around the Upper New York Bay. Though the Nature Interpretive Center is still closed due to Superstorm Sandy damage, the Nature Interpretative Center's Public Programs have continued.

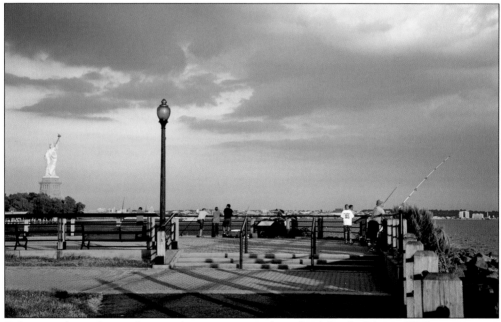

Fishermen favor the southern end waters surrounding the 1.5-mile Liberty Walkway, as seen above. Depending on the season, the waters hold winter flounder, blackfish, tomcod, summer flounder, bluefish, and striped bass. The fisherman on the right is looking southward toward the majestic Verrazano Narrows Bridge.

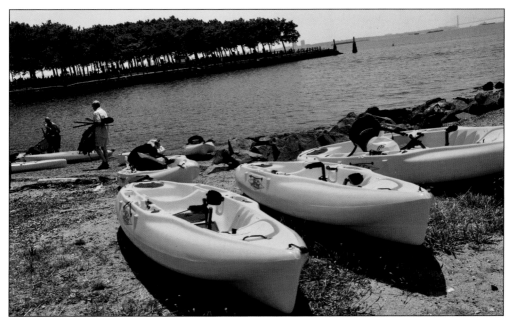

LSP's kayak eco-tours offer basic paddling instructions and the opportunity to observe the diversity of the Hudson River Estuary from a kayak. Caven Point Beach habitat provides a beachcombing stopover and a chance to discover horseshoe crabs, mud snails, mussels, and birds such as egrets, cormorants, herons, and osprey.

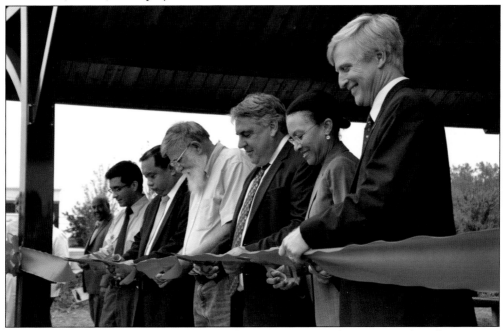

Pictured at the ribbon-cutting ceremony of the new picnic area featuring eco-friendly amenities and dramatic views are, from left to right, Robert Rodriguez, park superintendent; Councilman Rolando Lavarro; John Tichenor, past president FOLSP; Richard Boornazian, assistant commissioner of NJDEP Natural and Historic Resources; Michelle Richardson, director of Hudson County Parks and Community Services; and Mark Texel, director of the New Jersey State Park Service.

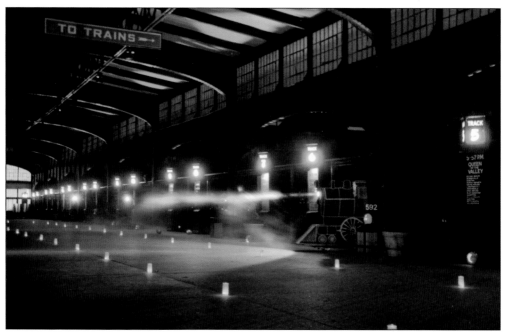

During LSP's Haunted Terminal Tour, visitors encounter the steamy image of an engine that once came into the train shed too fast, hitting the cast-iron bumpers but having enough momentum to travel halfway across the concourse floor—the area between the head house and gates to the trains!

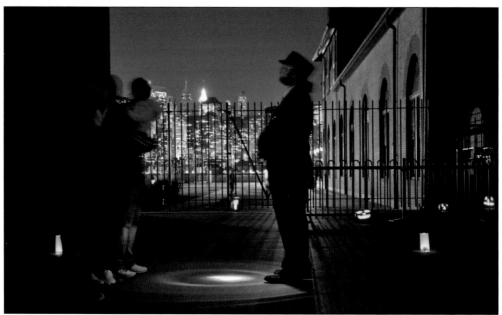

LSP began its Haunted Terminal Tours in 2009. Pictured here, guests are greeted by a ghostly CRRNJ conductor (historian emeritus Michael Timpanaro). With a flashlight, he guides visitors on a tour and hayride adventure through the terminal and grounds, recounting the site's haunted history, such as the mysterious Lady in White, whose flowing dress and wandering footsteps have been rumored to be seen throughout the terminal for over 50 years.

Six

THE "INTERIOR"

In the center of LSP, there remains approximately 251 acres of fenced-off land referred to as the Interior. This former railroad yard, abandoned since 1969, is the location of a unique habitat restoration project. New freshwater wetlands will be created, an emerging 100-acre forest preserved, and a large salt marsh is planned. Already, the area's bird list boasts 240 species! The most intriguing element of the restoration project is the use of the existing vegetation, common to the area, as an Urban Wildland.

The soils of the century-old rail yard present a challenge. They consist primarily of nonconsolidated fill from 1860 to 1919 construction projects in Manhattan or New York City and Jersey City refuse. The rubble was capped with cinder and ash creating a level and dense layer suitable for all rail operations. In addition, the 100 years of industrial use added a medley of contaminants, primarily metals, in concentrations above residential and ecological standards. In spite of the soil contamination issues, various plant communities dramatically colonized the area. Like the surrounding human community, they are diverse and have origins throughout the world. This diversity is further enhanced by the rapid rate of succession. As these plant communities develop over the years, adding organic matter to the poor soils of the rail yard, biological productivity and diversity has increased remarkably. The park's plant list currently includes over 300 species!

The emerging label for such plant communities is "novel assemblages"—groupings of both native and nonnative species—which appear to strengthen, support, and sustain significant ecological function. Found primarily in urban areas where human activities lead to the rapid distribution of nonnative plant species, these communities are often wonderful examples of nature's resiliency under extreme stress.

When opened, LSP's Interior natural area will offer visitors an unprecedented opportunity to experience the vitality of a truly historic recovery!

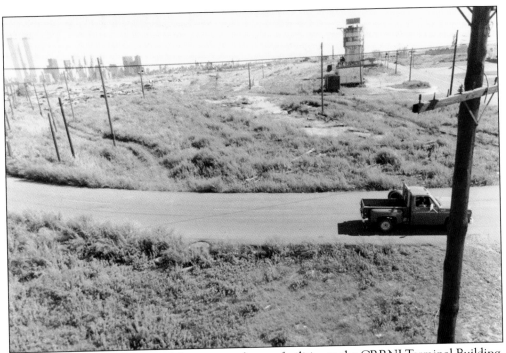

Conducting a 1979 inventory of the water and sewer facilities to the CRRNJ Terminal Building, this broad swath of undistinguishable land with remnant rail yard structures, skeletal fencing, and traces of gravel roads is now part of LSP's Interior. The Twin Towers, completed six years earlier, are in the distance. (Courtesy of LSPHA.)

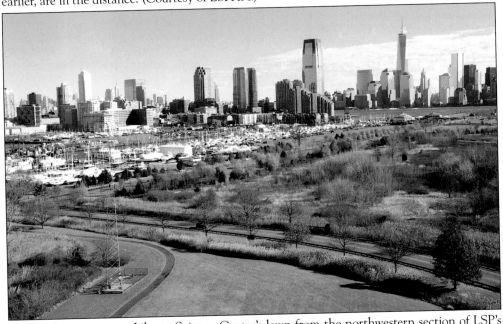

Phillips Drive separates Liberty Science Center's lawn from the northwestern section of LSP's Interior. A fence and line of trees, far left, define the Interior's northern boundary. Farther left, Audrey Zapp Drive extends east to Liberty Landing Marina, two restaurants, and *Empty Sky* memorial. New Jersey's Goldman Sachs Building faces New York City's Freedom Tower.

Claus Hozaphel (left), a plant ecologist at Rutgers, Newark, and Frank Gallagher, PhD, Rutgers, New Brunswick, led this tour through LSP's wildlands. They described the complex history of the Interior's unique habitat evolution and the breeding systems, diversity, invasion, seed ecology, root interactions, clonal plant biology, and species interaction.

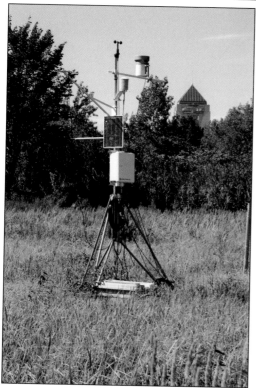

The eddy flux tower has been described as a bizarre galactic Christmas tree, especially when coated in snow! It is actually an atmospheric measurement system used to assess the concentration of carbon dioxide, water vapor, and, in essence, energy transfer. Carbon sequestration can then be calculated for the grasslands of the park.

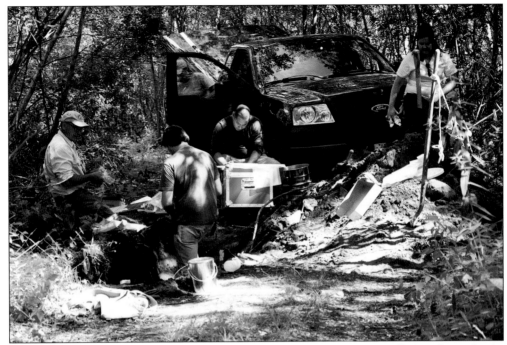

After "digging holes" in different areas of the Interior, USDA scientists collect soil samples for the purpose of classification. As a result of their analysis, the soil from LSP has been classified as the "Lady Liberty Series" and is used as a reference for urban soils from postindustrial sites.

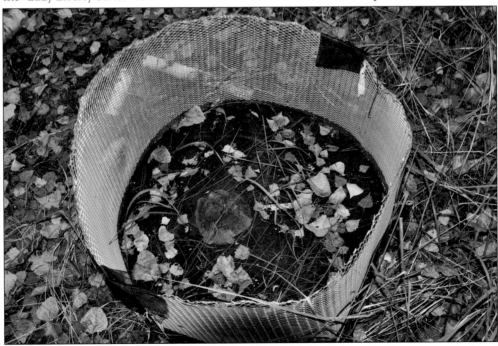

Leaf mass plays an important role in the temporary capture of carbon. A leaf litter trap is deployed to assess leaf mass deposited during autumn. The tree "cookie," also in the photograph, was weighed before it was put out. It will be weighed every three months to determine decay rate.

Sphagnum moss was an early colonizer of the gravel and coal spoils of this former rail yard. It can be found growing in dense cushiony "mats" throughout. Not dependant on soil water, the moss spreads into drier areas providing habitat for an array of plants and shrubs.

Pincushion moss, sometimes called mother's-in-law cushion, soaks up water, growing large enough to sit upon. Pincushion moss grows in the rocky soils of LSP. An earlier colonizer, this species facilitates the process of soil development throughout the Interior.

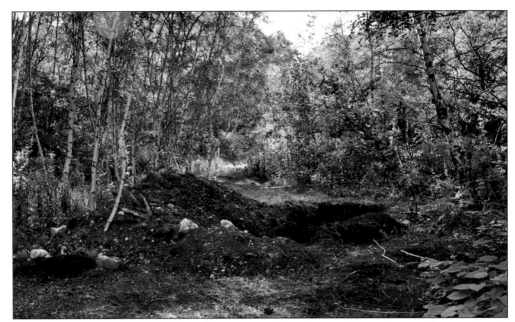

During the soil scientists' dig, remains of a centuries-old corduroy road were discovered approximately five feet below the current ground level. Historically, corduroy roads were built for several reasons. Made of logs laid transversely over low, impassable, or swampy areas to improve transportation, the name comes from the rough-ribbed wooden surface resembling corduroy fabric. This Interior corduroy road discovery was left open for archival research and archaeological reconnaissance surveys. Essential for establishing networks between communities and critical resources, constructed of white cedar, and buried within the water table, these planks have the potential to last for centuries.

The shelf fungi growing on this dead birch tree facilitate decay of the woody tissue, thereby recycling the tree's nutrients and carbon. A 5,000-year-old Tyrolean Ice Man mummy had this type of birch polypore in his possession, leading archeologists to speculate he may have used it for medicinal purposes.

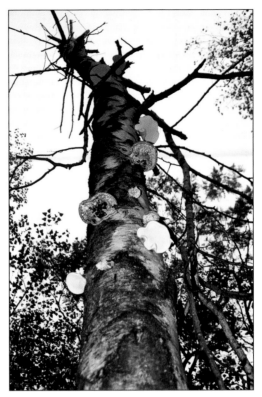

Placed within the Interior for research on metal transfer to nestling wrens, this bird box appears to have been taken over by squirrels. Note the rough clawed wood of the bird box's cavity and roof top edge. Wrens attempt to raise two broods or "clutches" of eggs per season.

The Interior is anchored at two sides of the park by the Nature Interpretive Center and the Liberty Science Center. If entering the restricted Interior's eastern end old field, pictured above, the shrub and tree communities framing the Liberty Science Center's blue triangular tower would not seem much of an obstruction. However, an attempted walk west toward the Liberty Science Center, pictured below, would be a challenging trek! Clumps of barbed bushes, vine-wrapped thickets, pesky ticks, birch and pine forests, and disappearing "trails" populate this untamed wildland. With the completion of the restoration project, the journey across the Interior would become a simple, enjoyable, and informative nature walk!

Gray birch and cottonwood dominate this pioneer urban forest. Early distribution of these species correlated well with high soil metal concentrations. Since they do not translocate most of the metal contaminants to the tree's aerial sections, they reduce the risk contaminants will move into the food chain, providing an ecological service.

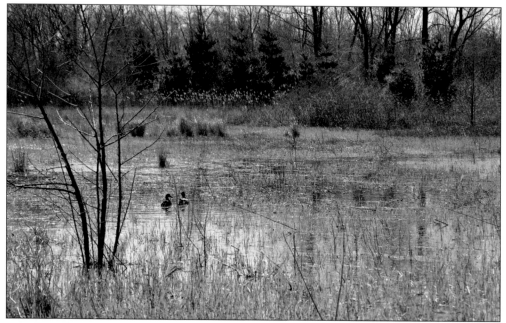

A mallard couple appears content to dabble about in this temporary "puddle pond." These birds avoid water more than a few feet deep. This newly created body of water in the center of the Interior's old field formed after a heavy rainfall, attracting the ducks to the reinvigorated vegetation below.

This mozzarella delivery truck lies upside down within the Interior's overgrowth. Long used as a dumping site, items unearthed during the years of construction in LSP revealed candleholders, creamers, artillery, and bottles of every type and function, such as perfume, milk, ink, liquor, and medicine. Most date from the late 1800s.

Old rail ties remind visitors to this birch forest of its past. In 1976, there were few expectations the area would recover from its history of industrial waste. Throughout the Interior, mounds of rail ties can be found, some lying transversely over the ground as if supporting unseen tracks.

A solar panel powers a data logger for the sap flow indicators placed on about a dozen trees within the Interior. Measuring sap flow every 30 minutes throughout the years, the data has demonstrated transportation rates in this urban forest. From this data, carbon sequestration can be calculated.

Old field is the first large area encountered when entering the Interior from Freedom Way. It is called old field because the grasses generally dominating early successional fields are giving way to forbes and woody shrubs found in fields with some age. The white multiflora rose (left) is traditionally considered invasive.

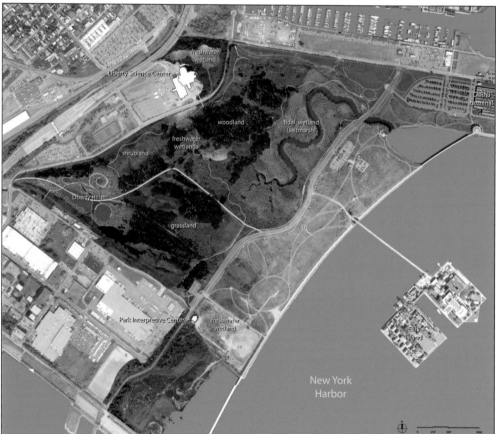

This illustrative Interior plan includes 36 acres of salt marsh, 28 acres of freshwater wetlands, 100 acres of woodlands, and approximately 60 acres of grassland. The project seeks to provide the public safe access into the site while allowing a productive range of habitats to flourish. Through a system of paths, visitors can experience both ecological and aesthetic assets. The site's complex history and shifting ecology is creating a new model for the 21st century urban park. (Courtesy of LSPHA.)

FRIENDS OF LIBERTY STATE PARK (FOLSP)

The Friends of Liberty State Park (FOLSP) is a nonprofit, 501(c) (3) organization dedicated to "preserving, protecting, conserving, and promoting" LSP. FOLSP is also an Officially Recognized Friends Organization (ORFO) of the New Jersey Department of Environmental Protection's Division of Parks and Forestry. Since its founding in 1988, this all-volunteer group has been devoted to the vision of a free, open, and green park for all people.

Often standing together with their main ally, New York/New Jersey Baykeeper, FOLSP has spearheaded statewide coalitions defeating several threatening and destructive commercialization plans such as a golf course and a water amusement park. Ever vigilant, FOLSP remains at the forefront, ready to defend public access to the "people's park," encouraging public participation in park decision making, and working with local and statewide citizens in shaping LSP for present and future generations.

FOLSP advocates and works for a broad range of park improvements. The group's popular and highly praised Volunteer Garden Program has funded tens of thousands of dollars on both trees and the park's 16 gardens. Experienced and inexperienced gardeners are invited to enjoy LSP while tending to its most fragrant and charming ground features. FOLSP also supports the park's nature and history programs and organizes an annual volunteer salt marsh cleanup to improve the Richard J. Sullivan Natural Area shoreline. FOLSP has contributed toward the building of a covered picnic pavilion in Freedom Field, with a scenic outlook set about landscaped paths. In addition, FOLSP has encouraged and supported the planned Interior nature restoration project. The Friends website is www.folsp.org.

DISCOVER THOUSANDS OF LOCAL HISTORY BOOKS
FEATURING MILLIONS OF VINTAGE IMAGES

Arcadia Publishing, the leading local history publisher in the United States, is committed to making history accessible and meaningful through publishing books that celebrate and preserve the heritage of America's people and places.

Find more books like this at
www.arcadiapublishing.com

Search for your hometown history, your old
stomping grounds, and even your favorite sports team.

Consistent with our mission to preserve history on a local level, this book was printed in South Carolina on American-made paper and manufactured entirely in the United States. Products carrying the accredited Forest Stewardship Council (FSC) label are printed on 100 percent FSC-certified paper.

MADE IN THE